IMAGES
of America

SOUTH CAROLINA
BLUES

IMAGES
of America

SOUTH CAROLINA
BLUES

Clair DeLune

ARCADIA
PUBLISHING

Published by Arcadia Publishing
Charleston, South Carolina

Library of Congress Control Number: 2015936000

For all general information, please contact Arcadia Publishing:
Telephone 843-853-2070
Fax 843-853-0044
E-mail sales@arcadiapublishing.com
For customer service and orders:
Toll-Free 1-888-313-2665

Visit us on the Internet at www.arcadiapublishing.com

It is from the blues that all that may be called American music derives its most distinctive characteristics.

—James Weldon Johnson (1871–1938), poet, diplomat, and American anthologist of black culture

CONTENTS

ACKNOWLEDGMENTS

This book is dedicated to the musicians represented visually in this brief love story about South Carolina blues, as well as the many who could not be represented.

My thanks go to the following:

To my mother for her way with words and to my father for his fortitude and strength. To my family and friends who encouraged me. To my writing and editing colleagues and mentors. To the talented, terrifically tenacious team at Arcadia, especially Liz Gurley and Maggie Bullwinkel who uplifted me to power through challenges.

To contributors who entrusted me with their personal photograph collections: Phyllis Ashley Beasley, Doug Allen, Cora Garmany (Nappy Brown), Drina and Drink Small, Mac Arnold, Marie Walker, Gene Lee, Tut Underwood, Shelley Magee, Freddie Vanderford, Gary Erwin, Elfi Hacker, and Daniel Coston.

To those who shared unique images and/or guidance: the University of South Carolina's Beth Bilderback, Ben Singleton, Greg Wilsbacher, Scott Allen, Brittany Braddock, Jen Wochner, Brian Cuthrell, and Saddler Taylor; Richland County Library's research staff, especially Lauren Smith; Derik Vanderford; Tim Smith and Papa Jazz Record Shoppe; Tim Harwell; Geoffrey Graves; Word of Mouth Productions; Don Bonds; Fairfield County Library and Historical Association; Alda Smith; Tom Davenport; Audre, Mose, and John Allison; Joseph G. Thomas; Jerry Bell; Dale Bailes; Aaron Smithers and the University of North Carolina at Chapel Hill's Wilson Library; South Carolina Department of Archives and History; McKissick Museum; Davis Coen; Rick Marsh; Cleve Edwards; William P. Gottlieb (and heirs); National Archives, Netherlands; Woody Windham; Family of Del Rae Moskowitz; LGB; Roy C. Hammond; Lionel deCoster (and heirs); John Hartness; George Fulton; Jim Corbett, Joy Walker, Parker Connor, Brett Bonner; Living Blues, Bobby Vanderwege; Carolina Downhome Blues Festival; Tim Duffy & Music Maker Relief Foundation; Katherine Davis; Skip Peter; Myra Ramsey; Jerry Cover; Willie Wells; Art Menius; Library of Congress (LOC); Smithsonian Folkways; musicologists Kip Lornell, Bruce Bastin, Peter Lowry; Ron Cohen; Photo-Sound Associates; the United States Postal Service; the University of South Carolina and WUSC-FM.

To those who notice something not represented—keep hunting those rare old photographs for volume two. Finally, to the incredibly special and inspirational Amy Rogers, Robbie Schultz, and RockyDawg Blues Defender, without whom this book would not exist. I am forever indebted to you all.

INTRODUCTION

Humans have a hardwired need to connect with other humans. Cultures that embrace the oral tradition know that stories and songs teach cultural heritage, values, and morality in addition to entertaining the community. Oral histories also instill a reverence for community elders, whose preservation has been crucial in maintaining unbroken community legacies passed down through time.

Although written history has somewhat diminished the need for oral histories, storytelling remains integral to modern culture because it scratches an itch that lies deep under humanity's skin—the urge to matter. That desire for legacy is at the core of all historical record-keeping, whether oral or written.

Ironically, blues music does not "get one down." Rather, it is sung to ease the mind and rid the heart of woe and misery through song and verse. Also seemingly ironic is the fact that the blues are often sung about celebratory events, but the roots of blues originate in tribal storytelling. So it is as much a case of reporting the good news as the bad news.

There are difficult sociological and societal issues presented here as well, including the subject of harsh mistreatment of some humans by others. That cruelty was as integral to the development of the blues as an emotion as it was to the development of the blues as a musical style lamenting harsh circumstances. Its inclusion is critical in order to provide a basis for the reader to gain a broader perspective and deeper understanding of the pain that caused the genesis and evolution of the genre. It is the author's hope to have treated those difficult topics sensitively and respectfully.

It is with gratitude that I began this project almost three years ago, and it is one that cannot be completed because the music lives on and the story continues to write itself. The lore in this book has come from 40-plus years of residence in my adopted state of South Carolina during which time I have been a blues fan, professor of roots music history courses at the University of South Carolina, historian, published author, de facto (yet unofficial and admittedly sometimes overwhelmed) archivist, music writer, photographer, publicist, and booking agent, as well as the host since 1990 of an educational radio program on blues history, WUSC-FM's longest-running program, the *Blues Moon with Clair DeLune*, where "Tuesday is Bluesday."

Material for this book was culled from hundreds of audio interviews, myriad blues recordings, and countless hours researching, teaching, and broadcasting about the blues, combined with thousands of photographs and ephemera gathered and contributed by musicians, music fans, music venues, libraries, museums, universities, and historical societies documenting blues history as it happened. That compilation was further winnowed down to these 200 or so images that provide a peek into the patchwork of the history of South Carolina's vast contribution to the American blues scene. It is hoped the reader will find it enjoyable as well as informative.

South Carolina Blues takes the reader on a journey that points the camera to stories of the human side of four centuries of blues music in the state. The vast majority of these images

have never been publicly available before, providing the reader that oft-desired fly-on-the-wall experience—in essence, an all-access pass. This story is digested from a huge host of historic events and people, and is not designed to serve as a comprehensive or academic history of the blues in South Carolina. Rather, this short treatment is intended as an affectionate collection of snapshots in time, lovingly compiled over many years from predominantly unique visuals, with some aggregated from images scattered across the Internet.

Writing about music is a challenge because an author must use visuals to describe an aural sensation, so the reader is welcomed to augment this book with recordings to expand his or her awareness about artists mentioned in this short sampler.

Not every South Carolina blues artist or venue is mentioned; the content was driven by the availability of material, with the biggest challenges in finding relevant material from the days when photography was expensive and its subjects were often those on the lower end of the socioeconomic scale, which includes blues musicians both then and now.

That makes the materials gathered from the family of the Ashley Plantation especially rare. There, Mabel Hammaker Ashley had the grace to create an early integrated musical experience with herself as chorus leader, as well as the singular foresight to commemorate it on film for generations to come.

We also pay tribute to others who made historic contributions to the South Carolina blues tapestry—sadly, too late for some. And we shine a light on living musicians who often experience the same fate as their predecessors—performing as unknown or underappreciated itinerant blues musicians of South Carolina.

Carolina bluesmen were at the core of the British blues invasion. While Peg Leg Sam and Pink Anderson, along with Floyd Council from North Carolina, were performing in near obscurity at carnivals and in medicine shows as barkers hawked their snake oil wares, England's Syd Barrett was listening to their 78-rpm recordings. Inspired, he named his then blues band Pink Floyd. Bands such as Pink Floyd, the early Rolling Stones, and Hot Tuna were among the many ensembles soaking up the history of South Carolina artists who had been long forgotten and neglected by their fellow Carolinians.

South Carolina has also been a hotbed of musical styles that have created four worldwide dance crazes. One of those, the Charleston, sprang from the humble roots of an orphanage for black children in the city of the same name.

So I welcome you to come on this journey with me as we explore where South Carolina blues began.

Walk the muddy roads leading out to cabins where a homemade guitar or a harmonica was the only entertainment anyone needed. Envision the stringed gourds and makeshift instruments that struck the first notes. Imagine hearing the gospel strains of one of the first integrated choirs and plantation bells that rang out freedom.

Sail back through time over the Atlantic Ocean to the roots of modern blues. Picture the griots, revered tribal historians in the savannas of Africa, entertaining their esteemed European visitors with early versions of blues songs, only to be cruelly enslaved and brought to Charleston Harbor.

That is where our story begins.

One

THE ROOTS OF BLUES IN SOUTH CAROLINA

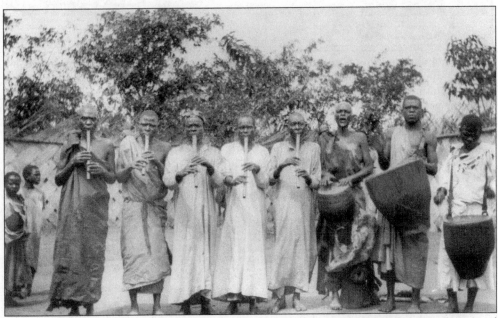

The roots of South Carolina blues, and all of American blues music, lie in Africa. History and heritage were tied together through the traditions of oral history and song. Tribal historians had the important role of passing down the tribe's history, including triumphs and tribulations and important folkways and moralities of the community, through storytelling and song, often interlaced with lessons. When African tribespeople were enslaved and sold in other countries, that tradition was disrupted. However, for those tribesmen who were storytellers, and for the music makers of the tribe, their communications traveled to the New World with the survivors and live on today as the root of much American music, including blues and its many offspring, such as jazz, rhythm and blues (R&B), and even rock-and-roll and rap. (Courtesy of LOC.)

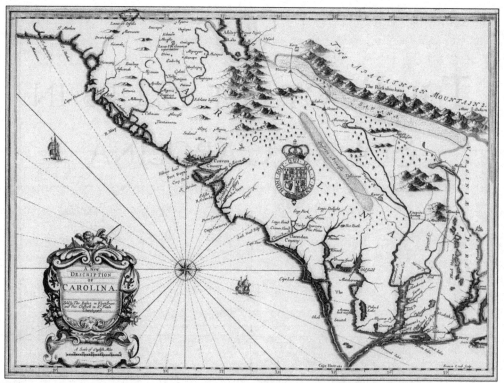

Percussion and drumming is an integral part of African music. West Africans in particular, who were shipped to the Americas during the active years of the slave trade, came from a very rhythmic culture that incorporated a heavy use of drums. Plantation owners feared rebellions, and many banned the use of drums because it served as a means of communication. Slaves on many plantations across the South relied on stringed instruments like the banjo, which evolved from a gourd with strings, or fiddles, which were European in origin. This is a map of Colonial Carolina prior to its division into North and South. In the Lowcountry of the Carolinas, near what was then called Hilton's Head, slaves were left to their own supervision for long periods each year, so much of the original African heritage was not stamped out in those areas, resulting in a unique blend of Afro-Carolina music. (Courtesy of LOC.)

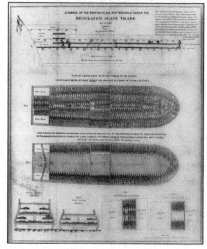

As evidenced by this etching of a ship's hold, slaves were treated as human cargo, and as such, they were barely fed and subject to disease while on the long voyages to their new "homes." To add indignity to the inhumane treatment slaves received, sailors would while away the long hours at sea by forcing their captives to sing and dance on deck for their entertainment. (Courtesy of LOC.)

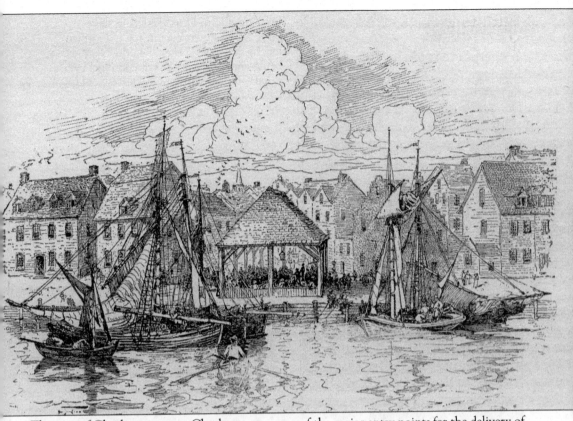

The port of Charlestown, now Charleston, was one of the major entry points for the delivery of slaves in America. The slave market is pictured behind these ships in Charlestown Harbor. (Courtesy of LOC.)

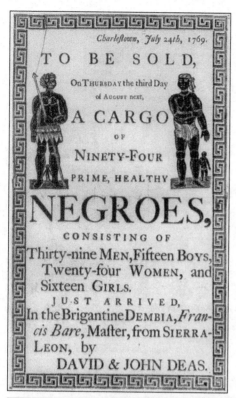

David and John Deas, dealers in slaves, posted this advertisement in Charlestown for the sale of 94 "prime, healthy Negroes" being imported from Sierra-Leon [sic] by shipmaster Francis Bare. (Courtesy of LOC.)

The auction block was similar from location to location, and most cities had a site near the center of town referred to as the slave market. There was a social aspect to these gatherings, and the landed gentry would make various business deals. The only people the horrors of these transactions were not lost on were those who were being bartered or sold. (Courtesy of LOC.)

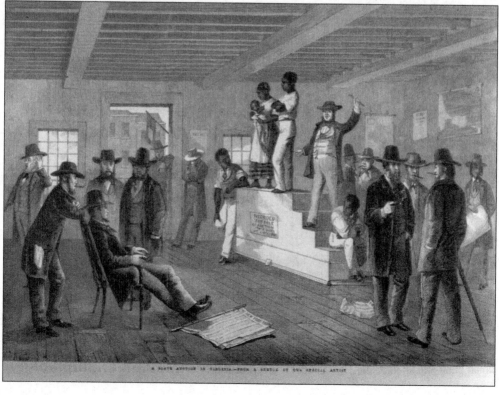

Acco of Sale / N 235 / Charges & Net Proceed of 112 new Negroe Slaves. Received by the
Schooner Polly Edward Boyd Commander from the Windward Coast of Africa. on Acct of Mess Willem
Davenport &c. owners of said Schooner. Merchants in Liverpool

Purchasers.	Men	Women	Boys	Girls	Terms of Payment.	Amount
1758						
July 4. Robert Raper	1.	.	.	1.	paid	1275. . .
George Cooper	.	.	1.	1.	£131.12/6 paid. Rem. next January.	450. . .
Stephen Frascad	.	.	1.	.	next January	210. . .
Elizabeth Charlar	.	.	1.	.	ditto	220. . .
Edward Weyman	1.	.	.	.	paid	260. . .
John Armpriester &						
Nich. Coldron	3	.	2.	.	next January	960. . .
Samuel Prioneau	1.	.	1.	.	paid	540. . .
Payl Douesaint	.	.	1.	1.	next September	420. . .
Samuel Severen	.	.	1.	1.	next January	380. . .
Sam. Wainwright	2.	.	.	.	next December	510. . .
Elizabeth Bean	.	.	.	1.	paid	160. . .
Charles Lewis	6.	.	.	.	next January	1500. . .
Job Rothmabler	6.	.	.	.	ditto	1500. . .
Estate of Royal Spry	4.	.	.	.	paid	1000. . .
Paul Smozier	.	.	2.	.	next January	350. . .
Jonathan Witter	.	.	1.	.	paid	230. . .
Benjamin Seabrook	1.	.	.	.	next November	260. . .
Richard Dowd	1.	1.	.	.	paid	500. . .
John Woolfall	3.	.	.	.	next January	750. . .
Capt Gibson	.	.	1.	.	paid	260. . .
John Jenkyns	2.	.	.	.	In next September. In next January.	500. . .
Thomas Hargrave	1.	.	.	.	in Do 3 months	260. . .
Abraham Spittied	.	.	1.	.	paid	195. . .
Samuel Severen	3.	.	.	.	next January	795. . .
William Woodrof	.	.	.	1.	next January	160. . .
William Walker	.	2.	.	.	next January	490. . .
Daniel Horry	.	.	9.	2.	in 12 months	2700. . .
7. William Vanvelsin &						
Will. Matthews	2.	.	.	.	next January	450. . .
Ancrum Lance & Cocock	1.	.	.	.	next September	225. . .
David Adams	3.	2.	.	.	next January	950. . .
Will. Bampfield &						
Geo. Appleby	15.	19.	.	.	next January	5725. . .
John Milner	.	.	.	2.	very small & sick. next January	160. . .
Men.	56.	20.	24.	12.		£23575. . .
Women.	20.					
Boys.	24.					
Girls.	12.	112 Slaves			Carried forward	

Logs were kept of slave purchases. As a general rule, only a first name was given to a slave. (Courtesy
of LOC.)

CASH!

All persons that have SLAVES to dispose of, will do well by giving me a call, as I will give the

HIGHEST PRICE FOR

Men, Women, &
CHILDREN.

Any person that wishes to sell, will call at Hill's tavern, or at Shannon Hill for me, and any information they want will be promptly attended to.

Thomas Griggs.

Charlestown, May 7, 1835.

PRINTED AT THE FREE PRESS OFFICE, CHARLESTOWN.

As seen on this sign, there was an active resale market as well. Thomas Griggs prominently posted offers to buy in Charlestown, directing sellers to "call" him via Hill's Tavern. (Courtesy of LOC.)

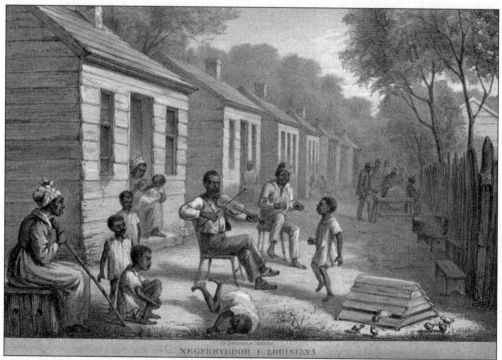

NEGERHYDDOR I. LOUISIANA

Once settled into their new homes, African American slaves relied on their musical roots to help them survive the many horrors of slavery. Once work was done for the day and their own needs had been tended to, there was often a communal gathering to share the comfort that music provided, allowing them to hearken back to happier times in their homeland. (Courtesy of LOC.)

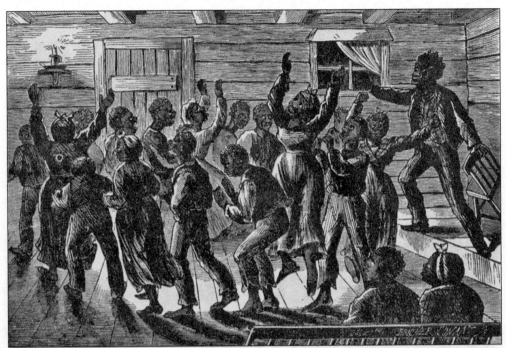

According to Charles Stearns's *The Black Man of the South*, a transitional mix of religions was not uncommon on plantations, with a combination of African, Christian, and sometimes Caribbean influences melding into what has evolved into Gullah, Geechee (or Geechie/Geeshie), and sometimes Vodun (also known as Vudu or VooDoo) religions. Prayer meetings were permitted as long as the worship appeared Christian. The ring shout worship, or dance, was popular in the Lowcountry and later evolved into "jump and shout" music and a number of Carolina dances based on African rhythms. (Courtesy of LOC.)

Living arrangements ranged from actual imprisonment in what were called slave pens to sparse, harsh, crowded, and bleak cabins or quarters to nicer accommodations in some areas. The Thomas Heyward Jr. home at 87 Church Street in Charleston shows kitchen quarters as they appeared in the 1800s and provides visual evidence that life was challenging and difficult for most people of that era, but especially arduous for slaves—even those who were provided the best of conditions, relatively speaking. (Courtesy of LOC.)

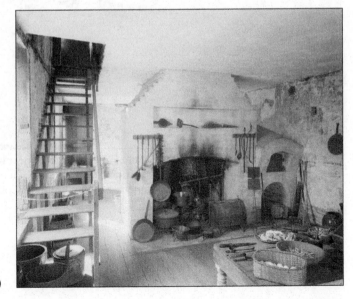

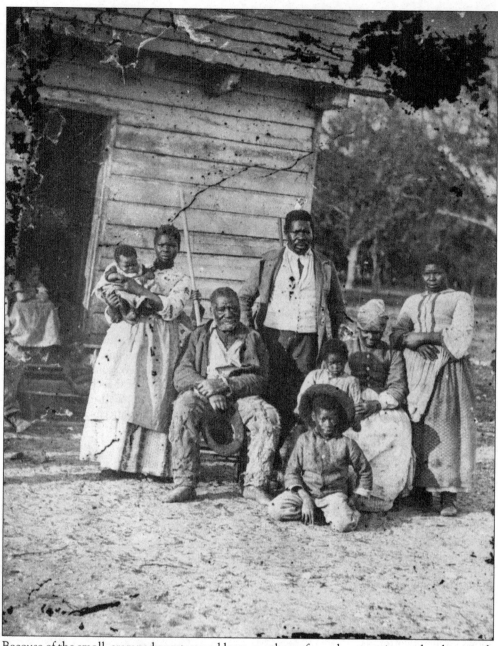

Because of the small, cramped quarters and large numbers of people occupying each cabin, much time was spent outdoors once the day's work had been done. Pictured here is a family gathered outside their one-room cabin near Beaufort, South Carolina. (Courtesy of LOC.)

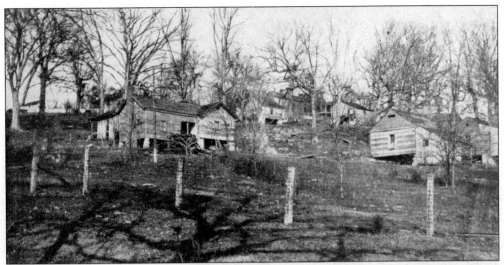

Some plantations had many slave cabins, which were usually nestled far away from view of the main house, past the outbuildings, which provided a certain level of privacy and allowed the pursuit of sometimes banned behaviors, such as music, dancing, religious pursuits, and the prohibited activity of learning to read and write. (Courtesy of LOC.)

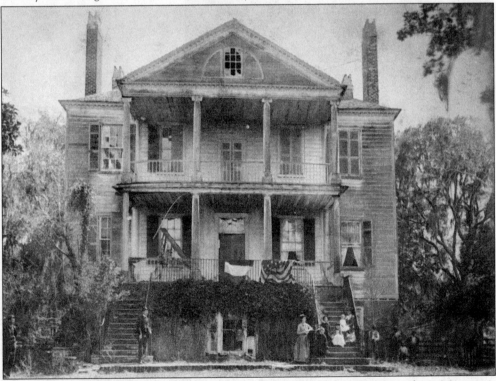

The main houses on plantations were not always as grand as Hollywood portrays them. Many were humble, and while some have crumbled, restoration has brought others back to their once elegant heydays. Pictured here is the Arcadia Plantation, located off US 17 on Arcadia Plantation Drive in Georgetown County. This photograph was taken in 1893, a time when money was scarce and the property had visibly deteriorated. It has since been restored. (Courtesy of LOC.)

Slaves in the field used low-pitched, rhythmic call-and-response work songs to pass the time and to keep the pace even, which was especially helpful for jobs that required timing and teamwork. Prior to the advent of the telephone, high-pitched field hollers carried a long way, fostering communication over distances. (Courtesy of LOC.)

Inexpensive instruments were important to early musicians. Gourds were plentiful in South Carolina and used, as they were in Africa, to make rudimentary instruments. The predecessor to the banjo was a stringed gourd, and the predecessor to the guitar was a diddley bow, which was a metal strand nailed to a board and plucked while pressing down on the fretless board. Manufactured instruments that were small and inexpensive, as seen in this harmonica advertisement, became popular because they provided three key elements: convenience, affordability, and portability. (Courtesy of LOC.)

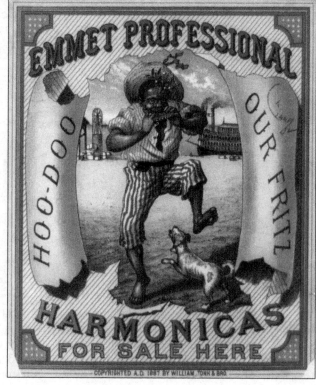

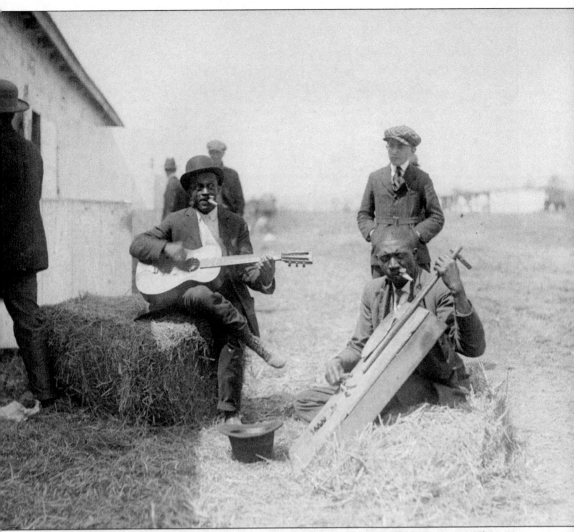

Here, one musician is playing a refined instrument and the other a rudimentary one. The man on the hay bale at left is much better attired and possesses a manufactured guitar. The man on the right is playing what appears to be a banjo made from a wooden shipping box, and his clothing shows wear and soil associated with hard work. The upturned hat indicates they might have met and agreed to busk together for tips. A young white male listens with great interest. (Courtesy of LOC.)

One can almost hear the wonderfully tinny plinkety-plink of the banjo strings as they are plucked by this gentleman in his hat and suspenders. Perched atop a stool, he keeps time by tapping the wooden planks on the porch with his work-worn brogan shoes. (Courtesy of LOC.)

73. THE RESURRECTION MORN.

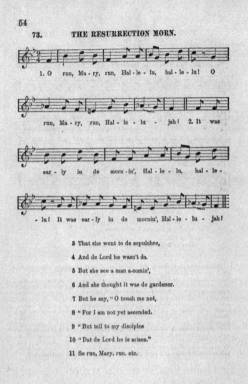

1. O run, Ma - ry, run, Hal - le - lu, hal - le - lu! O

run, Mary, run, Hal - le - lu - jah! 2. It was

ear - ly in de morn - in', Hal - le - lu, hal - le -

- lu! It was ear - ly in de mornin', Hal - le - lu - jah!

3 That she went to de sepulchre,

4 And de Lord he wasn't da.

5 But she see a man a-comin',

6 And she thought it was de gardener.

7 But he say, "O touch me not,

8 "For I am not yet ascended.

9 "But tell to my disciples

10 "Dat de Lord he is arisen."

11 So run, Mary, run, etc.

74. NOBODY KNOWS THE TROUBLE I'VE HAD.

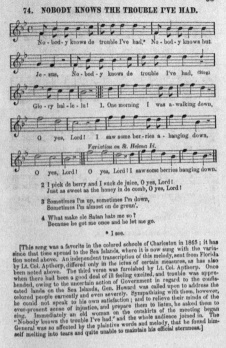

No - bod - y knows de trouble I've had,* No - bod - y knows but

Je - sus, No - bod - y knows de trouble I've had, (Sing)

Glo - ry hal - le - lu! 1. One morning I was a - walking down,

O yes, Lord! I saw some ber - ries a - hanging down,

Variation on St. Helena Id.

O yes, Lord! O yes, Lord! I saw some berries hanging down.

2 I pick de berry and I suck de juice, O yes, Lord!
 Just as sweet as the honey in de comb, O yes, Lord!

3 Sometimes I'm up, sometimes I'm down,
 Sometimes I'm almost on de groun'.

4 What make ole Satan hate me so?
 Because he got me once and he let me go.

* I see.

[This song was a favorite in the colored schools of Charleston in 1865; it has since that time spread to the Sea Islands, where it is now sung with the variation noted above. An independent transcription of this melody, sent from Florida by Lt. Col. Apthorp, differed only in the ictus of certain measures, as has also been noted above. The third verse was furnished by Lt. Col. Apthorp. Once when there had been a good deal of ill feeling excited, and trouble was apprehended, owing to the uncertain action of Government in regard to the confiscated lands on the Sea Islands, Gen. Howard was called upon to address the colored people earnestly and even severely. Sympathizing with them, however, he could not speak to his own satisfaction; and to relieve their minds of the ever-present sense of injustice, and prepare them to listen, he asked them to sing. Immediately an old woman on the outskirts of the meeting began "Nobody knows the trouble I've had," and the whole audience joined in. The General was so affected by the plaintive words and melody, that he found himself melting into tears and quite unable to maintain his official sternness.]

This compilation of sheet music for slave songs was published in 1867, shortly after emancipation. Many of these songs, which were transcribed note for note, have become musical standards of gospel and blues or serve as the inspiration for many others with a few chord or lyrical changes. (Courtesy of LOC.)

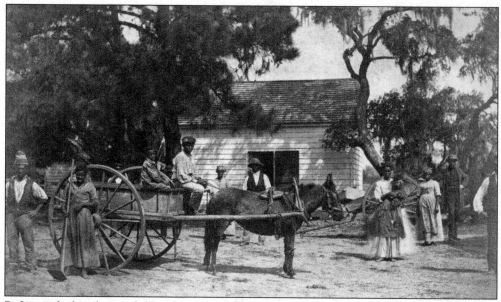

Before and after slavery, fieldwork was hard. Many blues musicians of the past century grew up picking cotton and credit their distaste for that type of manual labor as their inspiration to find a new way to make a living through music. Baskets or long fabric sacks filled with cotton weighed hundreds of pounds, making the work of picking cotton a backbreaking endeavor, and the sticky barbs holding the cotton boll onto the plant caused their hands to bleed, making it difficult to pick cotton by day and play a musical instrument by night. Rice cultivation was equally arduous and involved even more steps to produce. Here, slaves are preparing for the workday ahead, as depicted in Henry P. Moore's *Gwine to de Field*, which was titled using Gullah speech and photographed in 1862 on Hopkinson's Plantation on Edisto Island, South Carolina. (Courtesy of LOC.)

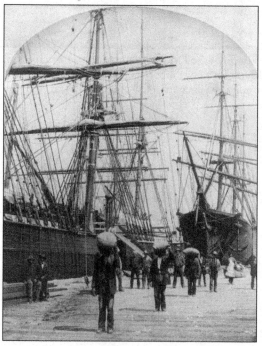

South Carolina's Lowcountry and Sea Islands were among the few places in the Americas suitable for rice cultivation. The complexities of planting rice and bringing it to market required specific skilled oversight. The rice-growing slaves of South Carolina were among the most autonomous in all of America. Here, workers on a Charleston dock are loading rice grown in the Lowcountry. Rice was shipped after it was winnowed by throwing it up in the air and catching the heavier grain in large baskets as the wind blew away the lighter husk. Handmade sea grass baskets are still sold by Gullah weavers along the coast. Songs and chants helped rice and cotton workers pass the time. (Courtesy of LOC.)

Two

The Early Years of Blues in South Carolina

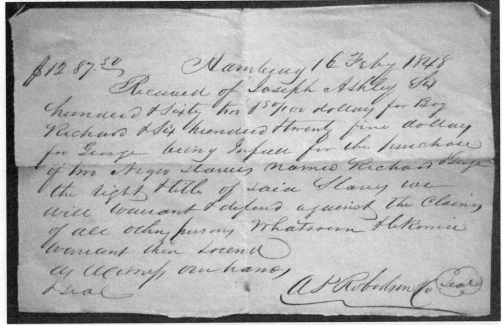

Although the importation of slavery was banned, the law permitted the sale of slaves until the Emancipation Proclamation ended slavery in the United States. The Ashley Plantation was a once thriving plantation in the southwest part of South Carolina, near the former town of Ellenton. The town and plantation were flooded when the Savannah River Site used the law of eminent domain to buy property needed for what is now the Savannah River Nuclear Site, but was known as "the bomb plant" when it was built to supply munitions for World War II. Treasured family heirlooms and papers as inconsequential as grocery lists were quickly moved from the plantation when government notices were distributed to leave the premises prior to flooding. Found stuck to the floor in an abandoned outbuilding, this slave receipt was recorded on plain paper with the following notation: "Received of Joseph Ashley six hundred & sixty & 50/100 dollars for Boy Richard & six hundred & twenty five dollars for George being infull for the purchase of two Negro slaves named Richard & George the rights & title of said slaves we will warrant & defend against the claims of all other persons whatsoever & be remise warrant their silence." (Courtesy of the Ashley family.)

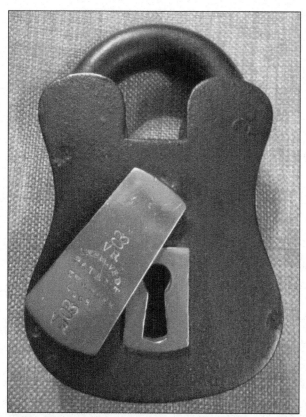

This immense lock with brass fittings was used in the meat storage building on the Ashley Plantation but appears hauntingly symbolic of the slaves' lack of freedom before emancipation. (Courtesy of the Ashley family.)

Still standing in 1980 on the property of a once fine plantation in Elko, Barnwell County, this typical outbuilding is representative of a style used for storage sheds, work sheds, and slave or sharecropper cabins. Although their design was intentionally rudimentary, neglect and disrepair have ravaged many of these historic outbuildings beyond the capacity for preservationists to save them. (Author's collection.)

State of South Carolina.

KNOW ALL MEN BY THESE PRESENTS,

THAT *I Elizabeth Gibson of the City of Charleston*

for and in consideration of *seven hundred dollars*

to *her* in hand paid, at and before the sealing and delivery of these presents, *by Jacob Martin &c*

(the receipt whereof *I do* hereby acknowledge) have bargained and sold and by these presents do bargain, sell and deliver to the said *Jacob Martin a certain Negro wench named Abba and her child Nelly together with her future issue and increase*

To HAVE and to HOLD the said *Negro wench Abba and her child Nelly & their issue and increase*

unto the said *Jacob Martin his*

executors, administrators and assigns to *his* own only proper use and behoof forever. And *I* the said *Elizabeth Gibson, my*

executors and administrators, the said bargained premises unto the said *Jacob Martin his* executors, administrators and assigns, from and against all persons, shall and will warrant and forever defend by these presents.

IN WITNESS Whereof *I* have hereunto set *my* Hand and seal Dated at *Charleston* on the *Twenty fourth* Day of *January* in the year of our Lord one thousand eight hundred and *Seventeen* and in the *forty first* Year of the Independence of the United States of America

Sealed and Delivered in presence of

Elizabeth Gibson {seal}
Alexr Gibson

John Strohecker

John Strohecker appeared before me and made oath that he saw Elizabeth Gibson and Alexander Gibson duly execute the within instrument for the purposes therein written

Sworn to this 29th Jan'y 1817

Recorded 29th Jan'y 1817

Elizabeth Gibson purchased freedom for "wench Abba and her child" for the sum of $700, to be released in the care of Abba's husband, Joseph Martin. In South Carolina, there were two types of slave work. One was dawn to dusk and provided little time for slaves to take care of their own needs, such as tending their gardens or making quilts to keep warm in uninsulated shacks. With the other type, called task work, if slaves got their tasks done, they were permitted to spend their remaining time in personal pursuits, which allowed them to employ their talents and capabilities in various endeavors, such as selling food from their gardens in town or performing blacksmithing or other trades for profit. Monies they generated often went to help others who were enslaved become free. This document shows that Gibson, already a freedwoman of Charleston, paid it forward by buying Abba and her child, then setting them free so they could be reunited with Abba's already-freed husband to live as a family. (Courtesy of South Carolina Department of Archives and History.)

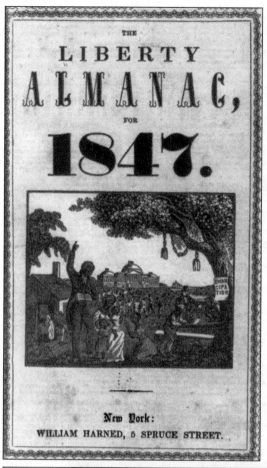

The Emancipation Proclamation of January 1, 1863, is preserved for posterity, but leading up to that date, many news articles, bills, and posters with vehement viewpoints on emancipation, both pro and con, were published. Few, if any, of those temporal publications were designed to be lasting documents. However, some have survived, such as this rare 1847 edition of the *Liberty Almanac*, depicting the publisher's prediction and anticipation of the end of slavery. A number of documents published after the proclamation that celebrated the emancipation of slaves have been conserved by the Library of Congress. (Courtesy of LOC.)

The exhilaration of freedom is captured in this handwoven linen, embroidered in brown thread on a cream background, showing two women dancing exuberantly above the words "We's Free." (Courtesy of McKissick Museum.)

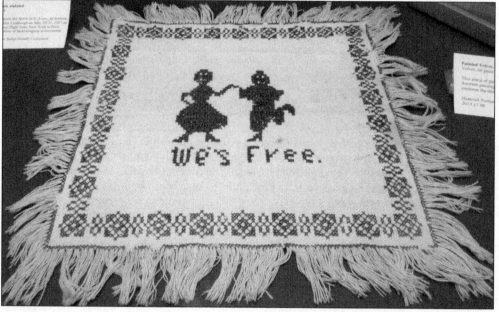

The plantation bells rang for many reasons, announcing the arrival of dawn, work shifts, meal times, and end of day, but the bell of freedom rang the loudest when emancipation came. There was a large migration of freed slaves to the north and west from owners who were cruel, but ironically, on some plantations known for poor treatment, many slaves stayed on after emancipation for fear of the unknown. Opportunities elsewhere were limited, and travel was dangerous; thus, many who were now freed stayed on their plantations as sharecroppers and domestic workers for many reasons, especially if the treatment on the plantation had not been sadistic. They also tended to stay if they had emotional bonds to their own extended family or the children of their former masters. Although many plantations cannot make the same claim, the Ashleys cite numerous letters from the family archives that provide documentation that no slaves left after emancipation because of the extremely strong ties to family, the plantation, and the community. (Courtesy of the Ashley family.)

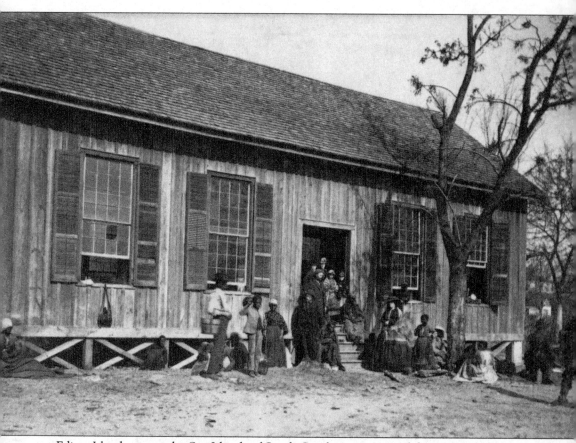

Edisto Island, among the Sea Islands of South Carolina, was one of the many island homes of the Gullah culture. Gullah, in South Carolina, and Geechee, in Georgia, are cultures borne of African slaves' importation into these states for their expertise in the cultivation of rice. The mix of new cultural influences and a rare autonomy led to the development of unique languages and traditions among those left unsupervised to run the rice fields for long periods each year. Boggy conditions that were perfect for rice growing resulted in huge mosquito populations as well, so plantation owners fled to the Midlands and the Upcountry to lessen their risk of contracting malaria, which was a leading cause of death in South Carolina in the 1700s and 1800s. This building on Edisto Island is notable in American history as one of the first schools for blacks. It is located in a remote area that was inaccessible at the time except by boat. The photographer's note indicates this landmark school could have been operational long before the laws making it illegal for a black person to be taught to read and write were struck down as unconstitutional. (Courtesy of LOC.)

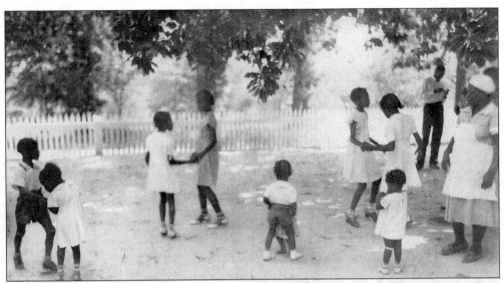

Children of sharecroppers dance and play in the yard under the watchful eye of a guardian. (Courtesy of the Ashley family.)

The cakewalk was one of the first dances to evolve from the African ring shout. Accompanied by fiddle or banjo music, blacks reportedly did a not-so-subtle mockery outdoors of the stiff elegance of white ballroom dances indoors, even as the whites unsuccessfully attempted to incorporate some of the freer movements of slave dances. As seeming proof the whites were unaware of the satirical nature of the dance, the custom of a prize began with a cake being presented to the couple that did the proudest movement. The cakewalk was popular for many decades and contributed to the evolution of subsequent dances based on African rhythms, such as the Charleston, the jitterbug, and the Big Apple, which in turn influenced the growth of blues, jazz, and ragtime music. (Courtesy of LOC.)

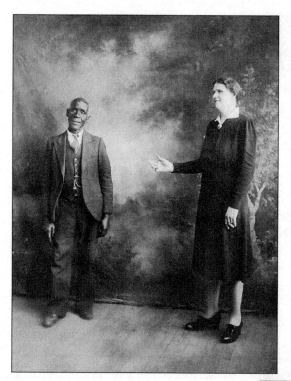

One of the first integrated singing groups emerged on the Ashley Plantation around the turn of the 20th century. Mabel Ashley organized what was then called a "Negro chorus" that performed each weekend. The soloist of the group is pictured here with Ashley. (Courtesy of the Ashley family.)

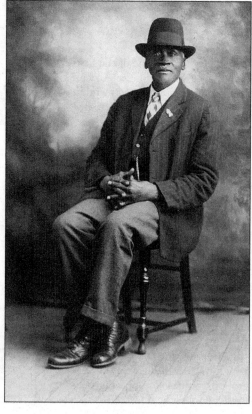

The esteem in which the soloist was held can be construed from this formal portrait, made at a time when hiring a photographer involved quite an expense. Thus, a photo session was utilized for only the most important visual commemorations. (Courtesy of the Ashley family.)

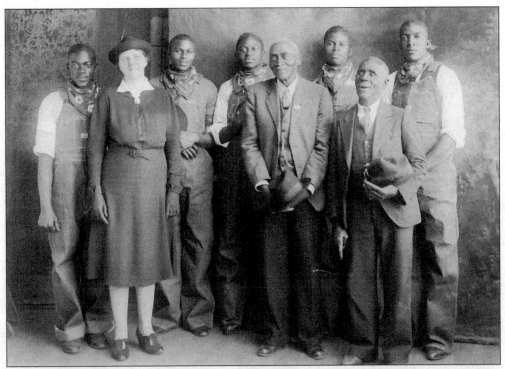

The Ashley Plantation singing group is pictured here with all members, including Mabel Ashley, the young choir, and the elder soloists. (Courtesy of the Ashley family.)

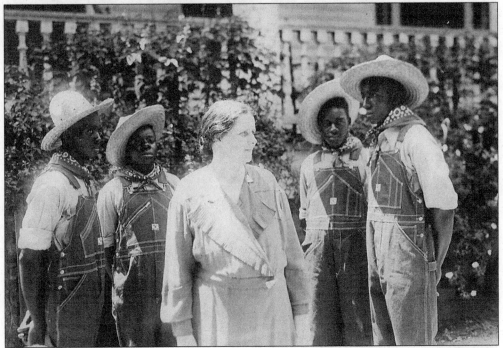

Casual outfits were the norm for sessions at home for the younger choir, who are pictured standing near the porch of the former Ashley Plantation homestead. (Courtesy of the Ashley family.)

Formal attire was donned when
the choir performed at church or in
town, and sometimes out of state.
(Courtesy of the Ashley family.)

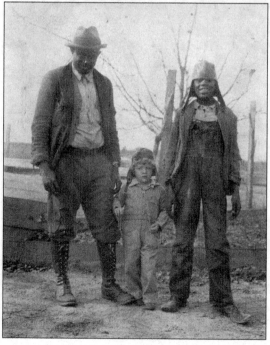

Mabel Ashley's son Joseph (center) is
pictured here with a favorite playmate.
(Courtesy of the Ashley family.)

During the Great Depression, many large plantations descended into decay. The Ashley Plantation survived through a partnership between the workers and the family by becoming a favorite destination for rich Northerners who wanted to experience life on an old Southern estate. The Ashley family credits these men for keeping the plantation from economic ruin because their expertise as guides made it a coveted destination for hunters. (Courtesy of the Ashley family.)

One of the earliest South Carolina bluesmen was Arthur "Peg Leg Sam" Jackson, who was born in Jonesville, South Carolina, in 1911 and died there 65 years later. His nickname came from the loss of his leg while hopping a train as a hobo during the Great Depression. He found an alternate career as a street busker, harmonica player, and comedian. Along with early players Pink Anderson, Simmie Dooley, Baby Tate, Cootie Stark, and the Reverend Gary Davis, as well as North Carolina artists like Floyd Council who came over the border to play, Jackson is considered one of the most important early bluesmen of the Piedmont, or East Coast, style of blues. The influence of these musicians' unique style was far-reaching, with the early-1960s British blues band Pink Floyd taking its name from the combination of Pink Anderson and Floyd Council. Jackson also mentored and influenced the career of Freddie Vanderford, who carries on his harmonica tradition today. In 1976, Tom Davenport released a biography of Jackson, *Born for Hard Luck: Peg Leg Sam Jackson*, and documentary footage is available at www.folkstreams.net. (Courtesy of Tom Davenport.)

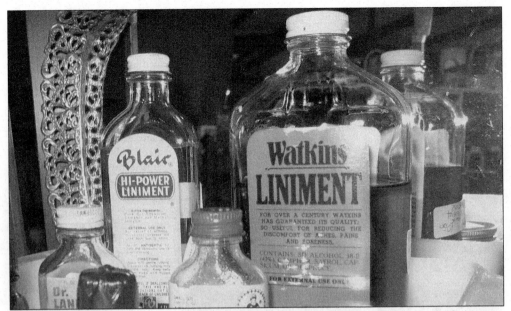

Jackson entertained prospects for medicine shows, drawing in customers from makeshift stages on patent medicine wagons selling their snake oil and other tonics and liniments from town to town across the South. (Author's collection.)

Although Jackson's final medicine show performance was in 1976, the sale of these tonics went on much longer in the Carolinas. The photograph of this sign was taken alongside a country road just off I-95 in the mid-1980s. (Author's collection.)

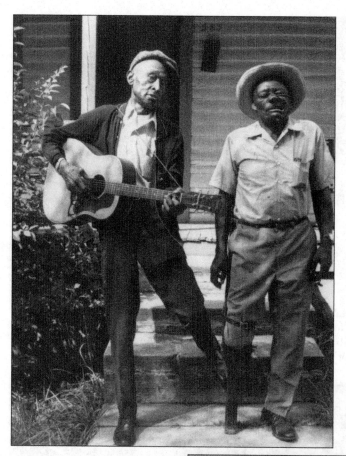

Pink Anderson's career began in 1914 when, at the age of 14, he joined Dr. William R. Kerr of the Indian Remedy Company, who sold tonics with "medicinal properties." Anderson is seen at left with Peg Leg Sam. Anderson's expertise attracted the attention of famed musicologists Paul Oliver, Peter B. Lowry, Bruce Bastin, Kip Lornell, and Paul Clayton. His recording career spanned many decades, and he mentored bluesman and historian Roy Book Binder, as well as his own son Alvin "Little Pink" Anderson. Pink Anderson's oft-covered songs "Greasy Greens," "He's in the Jailhouse Now," and "Chickens" still resonate today. (Photograph by Kip Lornell, courtesy of Southern Folklife Collection, Wilson Library, University of North Carolina at Chapel Hill.)

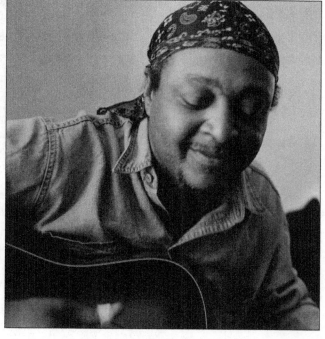

Little Pink Anderson plays his acoustic guitar in a reflective mood not long before leaving the Carolinas for a new home in the Dakotas. Little Pink's first band was the Legacy Duo, with Peg Leg's mentee Freddie Vanderford as a tribute to blues medicine show history. (Photograph by Tim Duffy, Music Maker Relief Foundation.)

Bertha Hill (pictured) and Clara Smith were two of South Carolina's finest contributions to the era of the classic blues women of the 1920s. One of 16 children, Hill ran away from home at age 11 to work in vaudeville for Ma Rainey's Rabbit Foot Minstrels. Known as "Chippie" because of her youth, Hill sang with Louis Armstrong. In 1950, she was killed by a hit-and-run driver. Spartanburg's Clara Smith recorded 122 sides, including "Black Woman's Blues." She began in vaudeville and toured on the Chitlin' Circuit. Clara gave 13-year-old Josephine Baker her entrée into show business as well. Bessie Smith and Clara were close friends until Bessie gave Clara a fierce beating. Clara performed until her death from a heart attack in 1935. (Courtesy of LOC.)

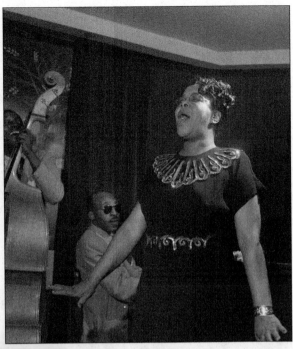

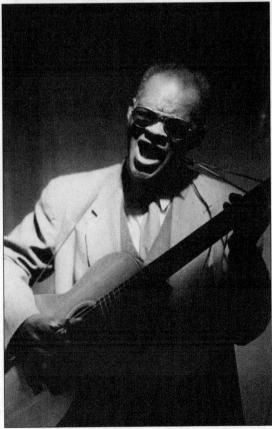

This rare photograph of the Reverend Gary Davis, who also recorded as "Blind Gary Davis," was taken at a New York City event called "Folk Festival at Town Hall" in 1958 and is part of the Ron Cohen Collection at the Louis Round Wilson Special Collections Library of the University of North Carolina at Chapel Hill. Born nearly blind in 1896 in Laurens, Davis taught himself guitar at the age of six, and garnered his ragtime style from an amalgam of gospel, ragtime, hokum, and marching band styles. He was inspired by Sam Brooks and Willie Walker, an early South Carolinian known for "South Carolina Rag." His contemporaries were Blind Arthur Blake, Blind Lemon Jefferson, and Blind Willie Johnson. A historic marker in downtown Durham, North Carolina, proclaims his importance as having been a major influence upon Blind Boy Fuller, who was one of North Carolina's most iconic players of Piedmont blues. (Photograph by Ray Sullivan of Photo-Sound Associates, NYC, courtesy of the Wilson Library, University of North Carolina at Chapel Hill.)

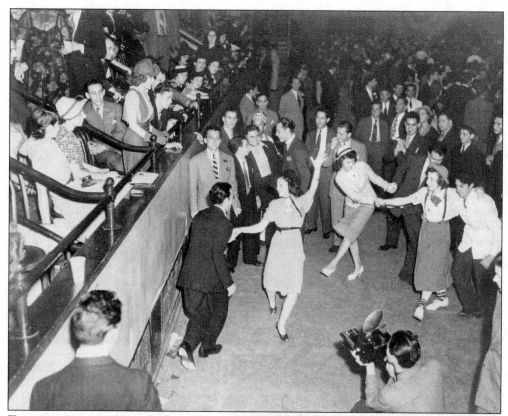

Tracing its roots to African rhythms, the jitterbug (also known as the Lindy Hop or swing dancing) emerged in the 1920s and stayed in vogue through World War II, then was revived in the 1950s for sock hops and soda parlor dances. Swing dancing has made a resurgence several times since, with a large revival in the 1990s. The most eminent modern practitioner of this musical style is Dick Goodwin, who is a distinguished professor emeritus and recipient of the University of South Carolina's prestigious Educational Foundation Award. Goodwin is the 2001 Elizabeth O'Neill Verner Individual Artist Award winner, which is the highest honor awarded in the arts by the State of South Carolina. (Courtesy of LOC.)

The Big Apple dance made its debut in the early 1930s at the former House of Peace Synagogue, a two-story wooden nightclub owned by Frank "Fat Sam" Boyd. The dance was invented by African American youth dancing a variation of the Gullah ring shout at what was then the Big Apple Club on Park Street in Columbia. (Courtesy of the Richland Library.)

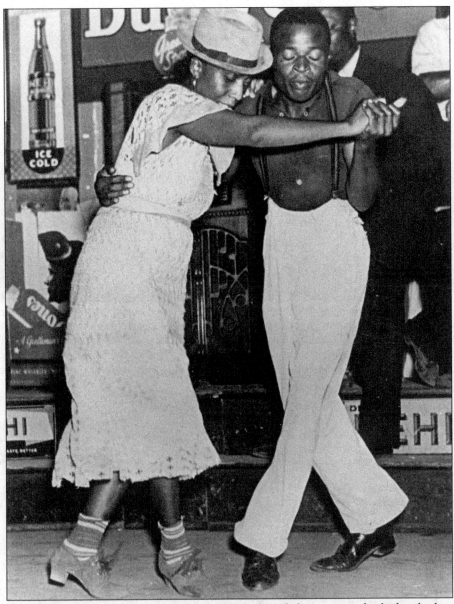

Three white University of South Carolina students heard the music and asked to be let in to see the dancing, which consisted of upbeat movements, counterclockwise circling, and high arm gestures with some tossing of the female partner. Although it was unusual for whites to be admitted to a black club, they were allowed into the balcony to observe for 25¢. They continued to "feed the nickelodeon" by tossing down nickels, because if the music stopped, so did the dancing. The craze hit New York City in the 1930s, thus becoming the second dance from South Carolina to take the nation, then the world, by storm. At the end of 1937, *Life* magazine featured the Big Apple in a four-page spread. *Life* predicted that 1937 would be remembered as the year of the Big Apple. Modern-day performers and dance artisans Richard Durlach and Breedlove embody the essence of the various swing styles of dance, as well as South Carolina's state dance, the shag. Durlach teaches at the University of South Carolina, while the duo performs throughout the state. (Courtesy of the Richland Library.)

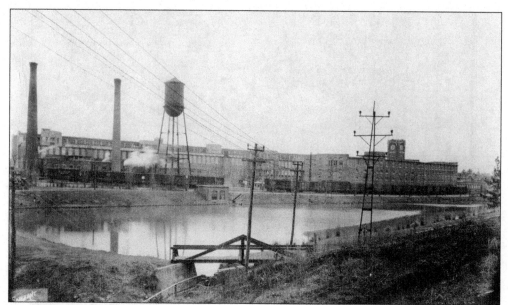

South Carolina life hit the musical map again when legendary Louisiana songster and performer Lead Belly recorded the song "Winnsboro Cotton Mill Blues." Seen from the back view, as only employees would, the mill's lake, water tower, and smokestacks are visible, painting a portrait of life in a mill town. The son of a lifelong mill worker there insists the song was written by "an unhappy worker," not by Lead Belly himself. (Courtesy of Don Bonds, via the Fairfield County Library and Museum.)

In the early 20th century, the Winnsboro Cotton Mill was an encapsulated community capable of serving its residents' needs. From left to right are a mill house (behind the tree), the mill hospital, mill tower, mill building, workers' houses (across the ridge), and whitewashed company store with a Ford Model T parked anachronistically next to a mule and wagon. The school and day care center is in the right foreground. (Courtesy of Don Bonds, via the Fairfield County Library and Museum.)

Cheraw hosts an annual jazz festival in honor of one of its greatest sons, Dizzy Gillespie. Gillespie's jazz notes were so complex that it is considered nearly impossible to imitate him. Taking blues roots into the worlds of jazz and bebop, Gillespie recorded on numerous labels, including the legendary Savoy, a blues and jazz label. He played for eight sitting presidents of the United States, forever placing his hometown on the world's musical map. (Courtesy of LOC.)

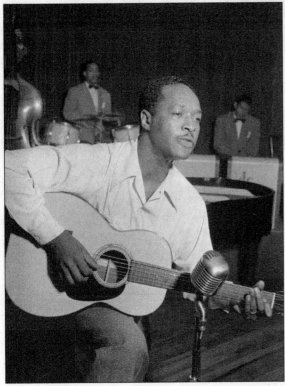

Joshua Daniel White, a Greenville native, left the state shortly after seeing his father beaten nearly to death by their landlord. He promised to make his mother proud, so he only recorded devilish or hokum blues under the pseudonyms "Pinewood Tom" and "Tippy Barton." As "the Elvis of his day," White was one of the most popular singers of the 1930s, becoming the first African American artist with a signature guitar line and the first to integrate a singing act with a white female partner. White was a friend and advisor to Pres. Franklin D. Roosevelt, but despite that connection, he was blacklisted for his songs about social injustice. (Courtesy of the William P. Gottlieb collection.)

41

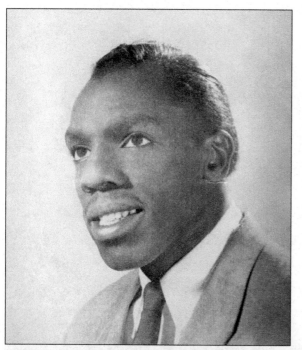

Napolean "Nappy" Brown was born in North Carolina but lived in Pomaria, South Carolina, most of his life. He recorded for Savoy in the 1950s and had a major hit with "Don't Be Angry," which dazzled his producer with its unusual, stuttering start. An earlier trendsetter, country guitarist Chris Bouchillon from Oconee, invented another popular style of music called "the talking blues," which became all the rage in the 1920s but soon faded into obscurity. Brown's work, however, blossomed from a trendy pop hit into a diverse range of gospel-based blues and R&B styles, paving the way for his induction into the North Carolina Music Hall of Fame in 2015. (Nappy Brown collection, courtesy of Cora Garmany.)

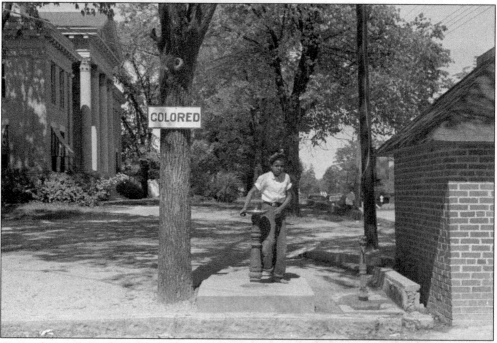

Even as late as the 1950s and 1960s, race relations made it difficult to travel and perform. Separate bathrooms, restaurants, and water fountains for blacks were the rule. It was challenging to be a traveling performer and find hotels that catered to black travelers, especially those in the music business. There were often signs at town limits reading, "Don't let the sun set on you in this town," providing a stark warning that those entering to perform work were not welcome there—or safe—after dusk. (Courtesy of LOC.)

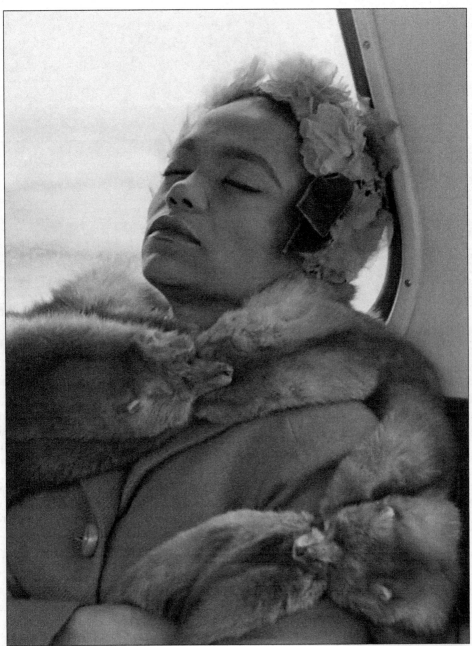

Although applauded at large arenas and auditoriums, "star treatment" sometimes consisted of a ticket on a bus. Eartha Mae Kitt, once called "the most exciting woman in the world" by Orson Welles, clearly shows the dichotomy of class distinction by wearing her elaborate fur coat while riding to her next performance on a bus. This native of the town of North, near Orangeburg, South Carolina, enjoyed several Top 10 hits, including the everlasting sexy Christmas classic, "Santa Baby." She leapt from recording into fame on stage and screen, being the first to purr her way through the kitschy role of Catwoman on the original *Batman* television series in the mid-1960s, bringing her sultry style to a new generation of admirers. (Courtesy of Het Genootschap, National Archives of the Netherlands.)

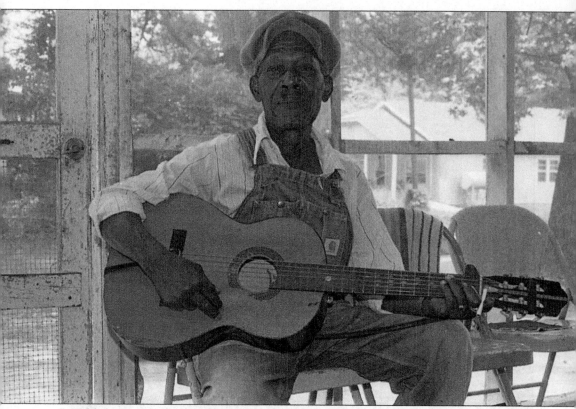

Sprinkled across the landscape of those artists who made a big name for themselves in the early part of the century are the hundreds of front porch pickers and music makers who are the opposite of a household name. They live in small towns, often out in the country in humble homes. They work difficult jobs, many times for low pay, and they worry, as many people do, about how they are going to pay the bills. In the time before radio and television, playing a musical instrument was often the only entertainment a family had. Sing-alongs and impromptu concerts among friends, and perhaps a paying gig for a party at times, were the norm. Artists who have grown up in obscurity but are bursting with natural talent are at the core of South Carolina blues. Pictured here is Willie "Big Boy" Tennant. (Courtesy of Saddler Taylor, McKissick Museum.)

Three

Mid-Century to Modern Blues in South Carolina

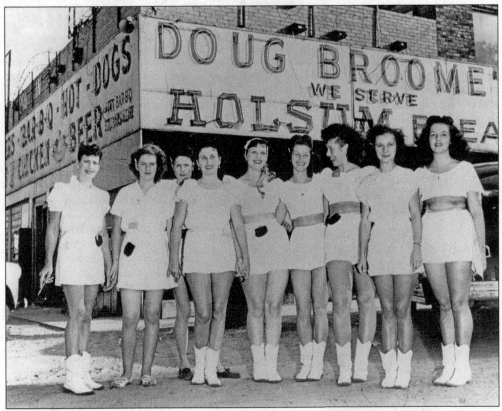

Drive-in restaurants became a mainstay of popular culture in the 1950s. They served as hot spots for youth who managed to borrow Daddy's car to cruise through the night. Like soda shops, they were the in-town teen "juke joints," providing a chance to socialize, dance, and sometimes even eat. A Big Joy burger and shake were the culinary highlights of the week for the average teen, who listened to the latest "top of the pops" hits while waiting for the food to be delivered car side. While there were many such spots across the state—with the Beacon in Spartanburg, the SkyView in Florence, and two Doug Broome locations in Columbia—few were chain restaurants. (Courtesy of the Richland Library.)

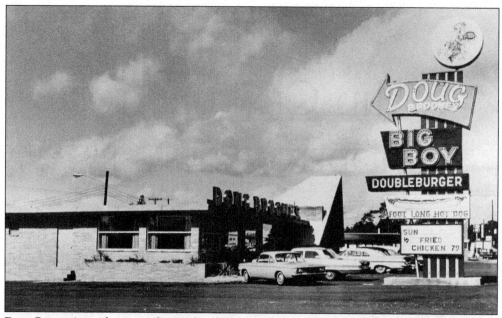

Doug Broome's two locations featured curb service while its Main Street location boasted its own radio broadcast for "teens on the scene," featuring Woody Windham spinning the platters as disc jockey "Woody with the Goodies." Teens spent time at juke joints like this dancing up a storm to the latest R&B, soul, and blues records, such as Nappy Brown's "Don't Be Angry" or Drink Small's first hit, "I Love You, Alberta." (Courtesy of the Richland Library.)

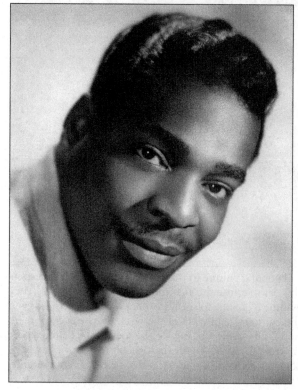

Brook Benton was born near Camden in 1931 as Benjamin Franklin Peay. Camden's Peay and Sumter's Bill Pinkney were close relatives and lifelong friends who grew up singing gospel, often in the same choir. While Peay was in the Sandmen, Okeh Records changed his name to feature him as a solo artist. Benton, who composed hits for singers like Nat King Cole and later recorded for Mercury Records, was urged to sing his own compositions and enjoyed many successes, including "Kiddio" and "It's Just a Matter of Time." R&B music fell out of favor during the British Invasion, but Benton had a comeback with "Rainy Night in Georgia" before dying of pneumonia and meningitis at age 56 in New York City. Benton is pictured here in a Mercury Records trade ad for *Billboard* in 1959. (Courtesy of Wikimedia Commons.)

Drink Small was born in Bishopville to a single mother in a family of sharecroppers. Small learned guitar from a man named only Greenback. After a terrible accident in his childhood in which he was run over by a heavily laden mule-drawn wagon, Small knew he would pursue a career in music. He played the Apollo in New York City as a guitarist and bass singer for the Spiritual Aires recording group. Sister Rosetta Tharp hired him to tour with her band, and in the early 1960s, he finally made the leap, as he describes it, "from Hallelu-jah to Boogaloo-ya," with his first recording, "I Love You, Alberta." (Courtesy of the Drink Small collection.)

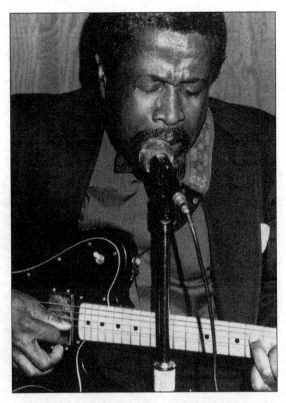

Dolores "Del Rae" Moskowitz caught the attention of the recording industry in 1974 when she was nominated for Grammy Awards in five categories: Song of the Year, Record of the Year, Best New Artist of the Year, Best Female Vocal Performer of the Year, and Best Instrumental Composition. Originally from Montgomery, Alabama, Moskowitz eventually moved to Orangeburg, South Carolina, where she passed away in 2012. (Courtesy of the Moskowitz family.)

47

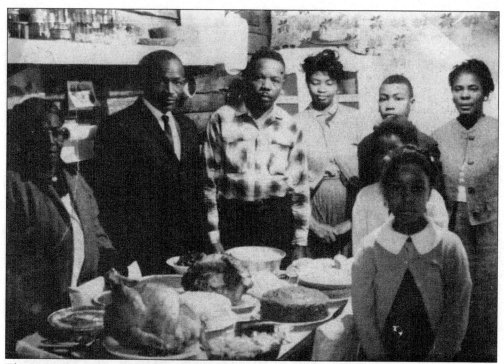

The 1950s was a time of change in America. Post–World War II elation had given way to the tensions of the Cold War with Communist bloc countries. What had been called "race music," which was segregated and targeted to the black community, was transitioning into R&B as it found its way across racial divides. Music served to grease the wheels of integration and understanding. The artist known as LGB is pictured celebrating Thanksgiving as a child in the 1950s. (Courtesy of LGB.)

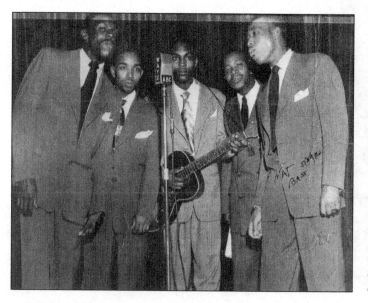

Napolean Brown Goodson Culp (left), who was then called "Nat," later became famous as "Nappy Brown." He provides bass notes for this early quintet as it performs on air for a Charlotte radio station. Harmony was a major part of the 1950s R&B sound, which would soon lay the foundation for rock-and-roll. (Nappy Brown collection, courtesy of Cora Garmany.)

Mac Arnold's roots are split between blues music and the soil. Arnold is pictured here as a young man poised to make the leap from a rural upbringing in the Upcountry of South Carolina to Chicago, the home of electrified blues. Arnold's first band featured an as-yet-unheard-of pianist from the Aiken–North Augusta area named James Brown, who later became world famous as "the Godfather of Soul." (Courtesy of Mac Arnold.)

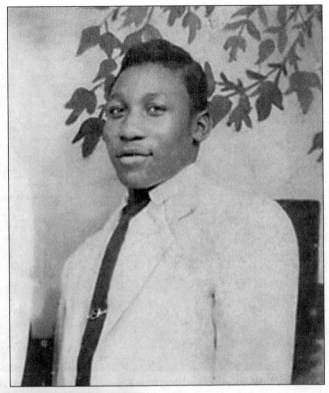

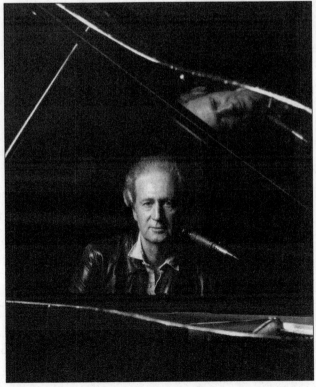

Mose Allison bridges the gap between jazz and blues music. Born in Tippo, Mississippi, Allison brings his early musical experience together with his work as a youth in the cotton fields. He has written over 150 songs, which he sings in a leisurely, laconic, truly Southern style, including the seminal "Parchman Farm" about life in a harsh Mississippi work-farm prison. Although Allison is not a native son, the warmth of Hilton Head's beaches and South Carolina's hospitality attracted him to adopt the state as his home. (Courtesy of the Mose Allison family.)

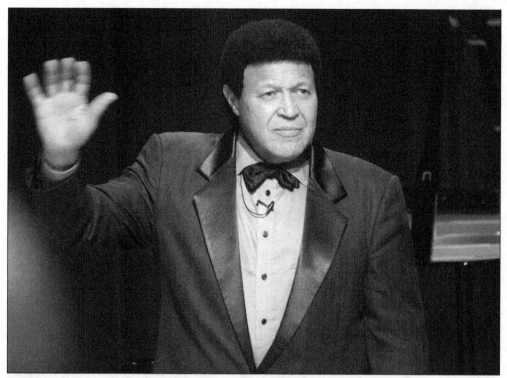

For a period of time, the rhythmic feet of South Carolina dancers seemed to generate an international dance craze every decade. The 1950s craze was the twist. Hank Ballard and the Midnighters originally released "The Twist" in 1959 as the throwaway B-side to Ballard's R&B hit "Teardrops on Your Letter." Legend has it that *American Bandstand*'s Dick Clark renamed Ernest Evans—born in Spring Gulley, near Andrews, South Carolina—as "Chubby Checker" to play on the popularity of Fats Domino. Checker's cover version hit number one twice. Checker is the only recording artist to place five albums in the top 12 all at once. He is shown here in a recent picture, looking as youthful as he did in the late 1950s when he was "twistin', twistin', twistin', 'til we tear the house down." (Photograph by Daniel Coston.)

Cootie Stark was born nearly blind as James or Johnny Miller in Abbeville around Christmas in 1927. His father gave him a guitar at the age of 14 because he had little chance of finding work because of his increasing blindness. Stark, whose pseudonym was a childhood nickname combined with his grandfather's last name, learned to busk on the street corners from the best in Piedmont blues—Baby Tate, Pink Anderson, and Arthur "Peg Leg" Jackson. Late in life, Stark was heard singing by Tim Duffy, of Music Maker Relief Foundation, who released his first album, entitled *Sugar Man*, another one of Stark's nicknames. Stark was honored with the state's folk heritage award in 2005, the year he died. (Photograph by Tim Duffy, courtesy of Music Maker Relief Foundation.)

Gene Lee and John Gallant founded the Crescents in 1958. The band consisted of three students from Eau Claire High School and two from University High in Columbia. There were only two or three bands in the city at the time. Being in the high school band at Eau Claire sparked the original trio's interest in music, thus laying the foundation for the creation of the band. It has been rumored that the drummer "borrowed" a bass drum from the school and painted the band's name on it. (Courtesy of Gene Lee.)

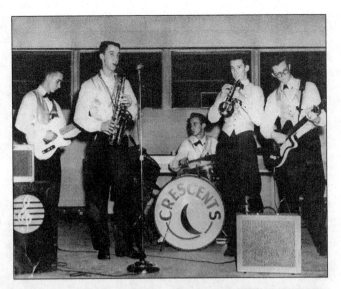

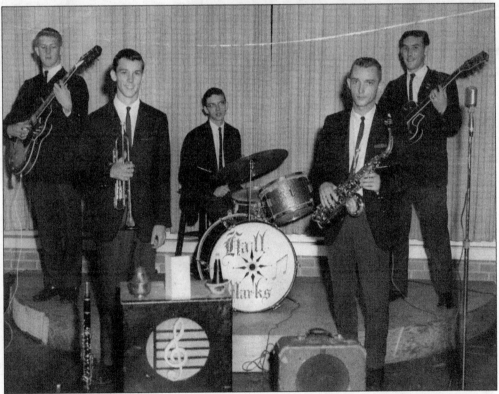

In 1960, horn player Gene Lee (second from left) morphed the Crescents into the Hallmarks. He says the name was inspired by the greeting card company of the same name because the members cared to "send the very best" music to the world. The initial lineup consisted of two students from Eau Claire High School, two from Columbia High, and one from University High. This picture was taken in 1961 when the Hallmarks played for Cardinal Newman High School's first junior-senior prom at the now demolished Downtowner Motel on Main Street in Columbia. They disbanded in 1964 when Lee left to join the military. (Courtesy of Gene Lee.)

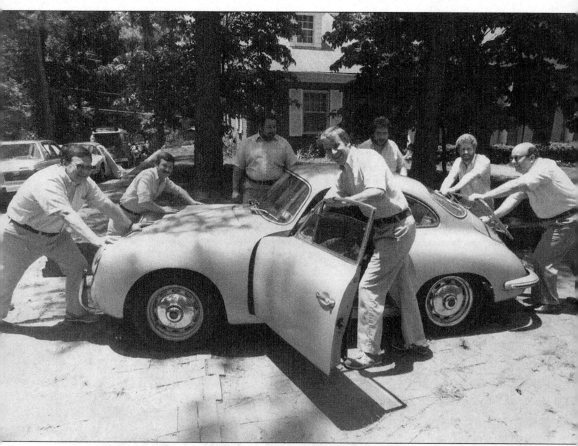

This photograph embodies a band's whimsical satire about a common problem for musicians—troublesome transportation. A musician is a troubadour, with the *t* for touring, transportation, trouble, and time. Transportation trouble is an occupational hazard. Sometimes, one must simply get out and push, but it might have been helpful if these fellows could have agreed on a direction. (Courtesy of Gene Lee.)

Blackville, Barnwell County, is the birthplace of James Benjamin "J.B." Hutto, who joined the Golden Crowns gospel group at age three, then rose to fame as a Chicago-style blues guitarist, playing a humble guitar sold in Montgomery Ward catalogs. He led the Houserockers after Hound Dog Taylor's death. Hutto was the crown prince of the slide guitar, with Elmore James as its undisputed king. Hutto's nephew Lil' Ed of the Blues Imperials carries on his legacy. (Photograph by Lionel deCoster, courtesy of Creative Commons 2.0.)

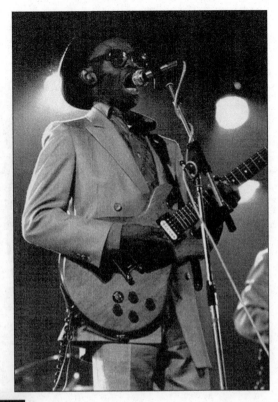

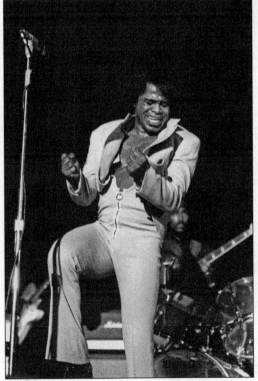

James Brown is seen here in February 1973 performing live in Hamburg, Germany, at the peak of his career as "the Godfather of Soul." Born to a teenaged mother and a young father in a wooden shack in Barnwell, Brown was raised in Elko, then in his aunt's brothel. Brown captured the drumbeats of African rhythms to create a unique style of funk music, providing the platform for rap and many modern musical genres. Keith Richards of the blues-roots-based British invasion band the Rolling Stones has often been quoted as saying, "Choosing to follow James Brown and the Famous Flames [on the *T.A.M.I. Show*] was the biggest mistake of our careers." (Photograph by Heinrich Klaffs, courtesy of Creative Commons 2.0.)

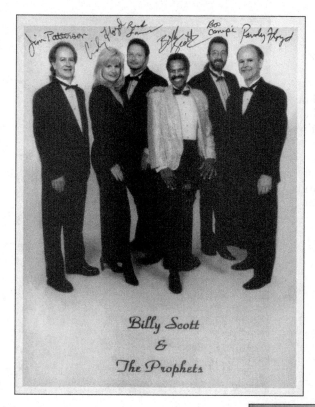

Billy Scott & The Prophets

Billy Scott was not born in South Carolina, but throughout his life, he played so much beach, R&B, soul, and blues music in the state that many consider him a native son. After being a singer while in the Army, Scott fronted a band called the Prophets, later renamed the Georgia Prophets. No beach party was complete without his recordings, especially a rendition of "I Got the Fever," which garnered this personable man his first gold record. (Courtesy of Gene Lee.)

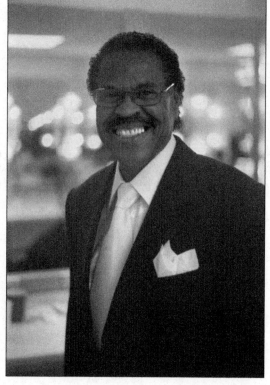

Born Peter Pendleton, Billy Scott continued to work until his death from pancreatic cancer in November 2012. His trademark smile is showcased here in an image taken near the end of his life. His warm demeanor was as much of an attraction to see his final band, Billy Scott and the Party Prophets, as was his voice and danceable music. (Photograph by Daniel Coston.)

The harmonies of the Drifters were among the best of the hundreds of doo-wop singers of the 1950s and 1960s. Formed in 1953, the band had many hits, including the number one "Money Honey." At the turn of the millennium, the Drifters were named in the top 20 of Time Life's list of "Top 100 Most Influential Rock and Roll Artists of All Time." (Courtesy of Gene Lee.)

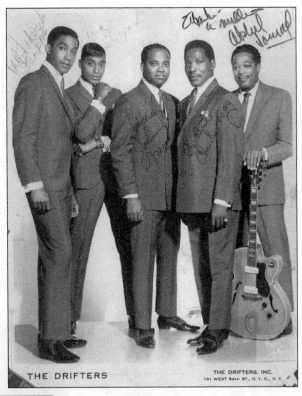

THE DRIFTERS

THE DRIFTERS, INC.
161 WEST 54th ST., N. Y. C., N. Y.

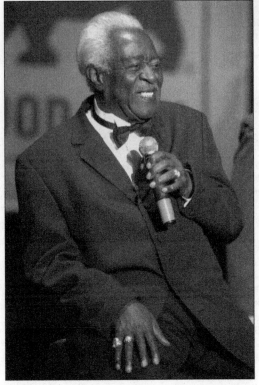

The Drifters were led by vocalist Bill Pinkney, who was born in Dalzell, near Sumter. He was the last surviving member of the original Drifters, featuring Clyde McPhatter. Pinkney grew up on a farm and maintained a close friendship with fellow South Carolina singer Brook Benton from childhood. Pinkney was given an honorary doctorate from Coastal Carolina University a few years before his death in 2007. (Photograph by Daniel Coston.)

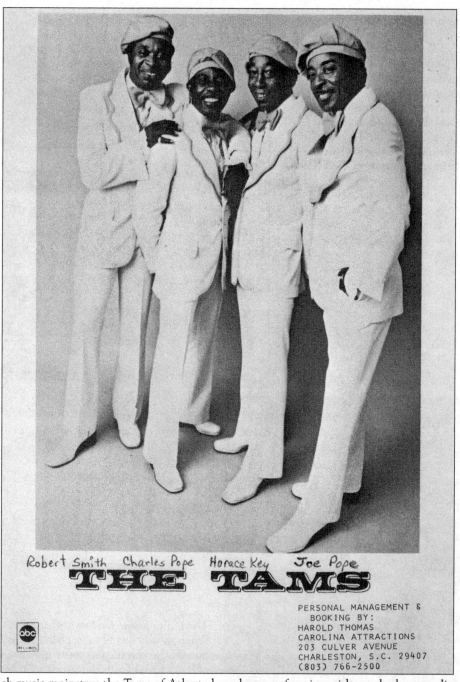

Robert Smith Charles Pope Horace Key Joe Pope

THE TAMS

PERSONAL MANAGEMENT &
BOOKING BY:
HAROLD THOMAS
CAROLINA ATTRACTIONS
203 CULVER AVENUE
CHARLESTON, S.C. 29407
(803) 766-2500

Beach music mainstays the Tams of Atlanta have been performing with nearly the same lineup since the 1960s. The group's connection to South Carolina roots music stems from its association with the state dance, the shag, which is a much slower version of the jitterbug. Born of humid beach nights at the Ocean Drive and Myrtle Beach Pavilions, the shag was designed to let the male partner be the peacock, while the female partner serves as a backdrop to better showcase her partner's fancy, if slow and deliberate, footwork. The Tams had several hits, some of which were regional, while others are featured in the movie *Shag*. (Courtesy of Gene Lee.)

Maurice Williams, seen here during a recent recording session, was born in Lancaster in 1938 and got his vocal chops the Carolina way—by singing gospel music in church. His enduring fame came from the beach and party music classic "Stay," written by Columbia's Homer Fesperman near the University of South Carolina campus. It is the shortest song to hit number one on the Top 40 charts. The Royal Charms, Williams's first recorded act, later became the Charms, then the Gladiolas in 1957, the Excellos in 1958, and finally, the Zodiacs in 1959. (Photograph by Daniel Coston.)

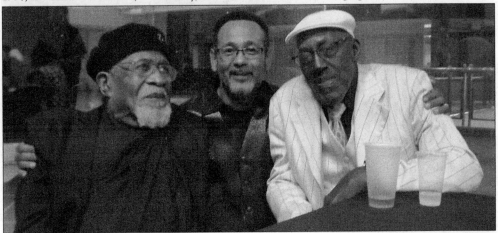

From left to right, Drink Small, Donald Ceasar, and Ironing Board Sam are pictured at a 2012 performance atop Richland Mall in Forest Acres. Ironing Board Sam was born as Sammie Moore in Rock Hill in 1939. The energetic and frenetic Moore performed a series of individual sets, followed by an exuberant final set with Small and Ceasar on drums and vocals. Moore, who got his nickname from playing a legless keyboard that he placed on an ironing board at gigs, had a then unknown Jimi Hendrix in his band in the early 1960s. Often categorized as a novelty act because of his use of gimmicks and antics, Moore is a gifted singer, as well as keyboardist, showman, and performer. (Author's collection.)

Born on St. Helena Island near Beaufort, "Cool John" Ferguson was raised in the Gullah tradition. By age five, he had taught himself how to play guitar and was performing professionally on television. According to Ferguson, "A lot of my people came out of the Gullah tradition, with roots in Western Africa, hard work and a hard life on the plantations, and worship in praise houses." His talent and dedication have led to Ferguson's selection as *Living Blues* magazine's "most outstanding guitarist" for two consecutive years. (Photograph by Daniel Coston.)

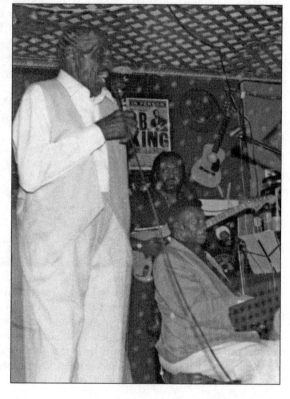

Kip Anderson, born Kiphling Taquana Anderson in the town of Starr, in Anderson County, was a label mate and friend of Nappy Brown and Drink Small. Anderson recorded on the Vee-Jay, Checker, Excello, and Ichiban labels. Small and Anderson were recording their first 45 rpms at the same time, so Small was asked to play guitar on Anderson's 1959 debut single, "I Wanna Be the Only One." After a struggle with drug dependency and a resultant 10-year prison term, Anderson worked as a disc jockey, eventually returning to music with a Checker release and CD duet with Nappy Brown (pictured at left, with Anderson on piano). Anderson died in 2007 at the age of 69. (Photograph by Daniel Coston.)

Doug Allen has been a South Carolina mainstay of the blues and jazz scene since the late 1960s. From competing in high school battle of the bands contests in the Midlands to performing in top blues rock bands of the 1970s and 1980s, from providing a sideman's soft jazz riffs and beach music thrills to being on the road with Motown's Mary Wells, G.C. Cameron of the Spinners and Temptations, and Billy Joe Royal to being Drink Small's go-to backing band member of choice for over 40 years, Allen is the performer's performer. Quietly understated, Allen's impact on the music scene in South Carolina speaks volumes, with his latest contribution as cofounder and coordinator of the Columbia Blues Mob, a local blues appreciation society, which is heavily populated with many talented musicians and fans in the Midlands and far beyond. (Courtesy of Doug Allen.)

The Lion band, pictured in Columbia around 1972, features, from left to right, Doug Allen, Trip Khalaf, Steve Burgess, Cleve Edwards, and Rick Peterson (seated, center). In another tie to South Carolina's blues heritage, Khalaf later became the tour manager for Pink Floyd's Roger Waters. (Courtesy of Doug Allen.)

Joanie and Friends rose to local fame playing the cavernous clubs of Down Under Columbia, such as the Scarlet Pumpernickel. Joanie's star rose because of her powerful vocals, and her ear for talent led her to choose cream-of-the-crop musicians like those pictured here. From left to right are Frank Smoak on guitar, Doug Allen on bass, and Rick Peterson on drums. Joanie is married to blues guitarist Parker Conner, whom she met in a later iteration of her band. Peterson's first band, the Mod VI, a garage blues band he joined as a freshman in high school, often toured with R&B and beach music sensations the Swingin' Medallions of Greenwood, South Carolina, who had a national hit with "Double Shot of My Baby's Love." Both the Mod VI and Swingin' Medallions appeared on *American Bandstand*. Notably, Peterson's mother was a dancer who, in her youth, helped introduce the Big Apple dance to New York City. (Courtesy of Parker Conner.)

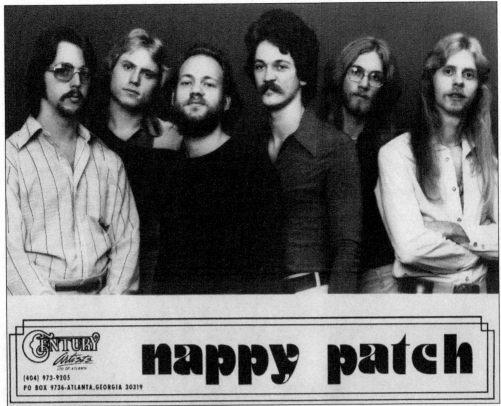

nappy patch

ᴄᴇɴᴛᴜʀʏ artists Ltd of Atlanta

(404) 973-9205
PO BOX 9736-ATLANTA,GEORGIA 30319

On the heels of Lion's breakup in the mid-1970s, a jazz, blues, rock fusion band emerged in Columbia. Nappy Patch featured original compositions and covers of jazz-rock with an underlayment of African rhythms. Employing two drummers (kit and congas), keyboards, saxophone, bass, and guitar, the band forcefully communicated its musical messages. From left to right, Steve Klinck (congas), Cleve Edwards (keyboards), Bob Fowler (sax), Jay Trapp (bass), George Stallings (drums), and Jim Corbett (guitar) opened for numerous national acts. (Courtesy of Jim Corbett.)

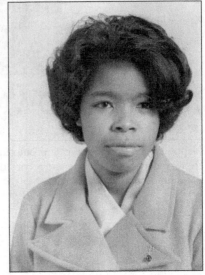

LGB, who originally hails from Allendale, South Carolina, but now resides in Warner Robins, Georgia, is a recent addition to the list of Carolina songbirds, but in the few years she has performed professionally, LGB (which stands for Linda Gray Barnwell) has issued several albums and garnered two award nominations. Citing her influences as rock, blues, R&B, beach, and zydeco, she sings original music with a gospel flair. Her latest album, *I Am Who I Am*, pairs her with the legendary Drink Small on "You Don't Miss Your Water." Her musical mentor is Roy C. (Courtesy of LGB.)

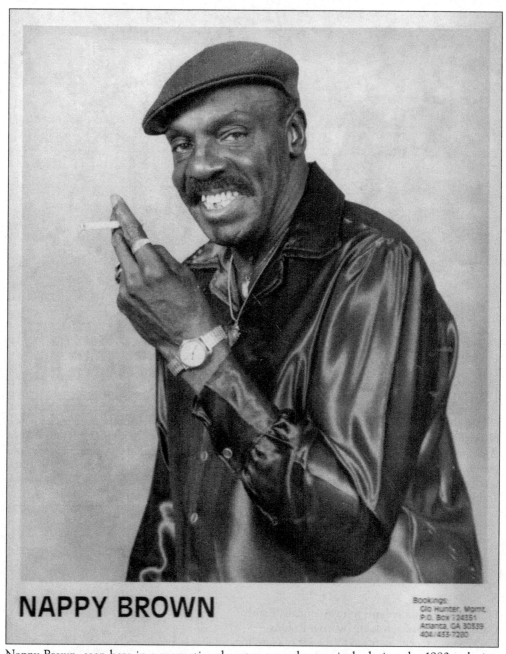

NAPPY BROWN

Nappy Brown, seen here in a promotional poster, toured extensively during the 1980s, playing shows in Japan and France and recording in the Netherlands. (Nappy Brown collection, courtesy of Cora Garmany.)

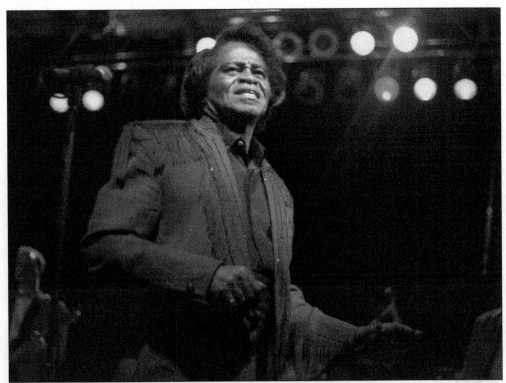

James Brown, pictured here late in his career, ran the gamut from low to high and back down to low again before regaining his stature as one of the top entertainers in the world just prior to his death. *Rolling Stone* magazine includes four of his albums in its 2003 list of Top 100 Albums of All Time. Brown is ranked seventh on the magazine's list of Top Performers of All Time. (Photograph by Daniel Coston.)

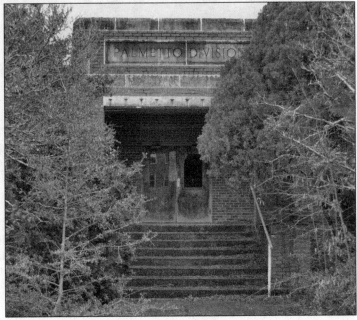

This is the now derelict Palmetto Division building where James Brown was reportedly incarcerated during one of his many prison stints in South Carolina. His first term was at age 16; he was arrested several times in the 1980s and 1990s. Authorities often responded to calls about domestic violence at Brown's home. (Courtesy of Tim Harwell.)

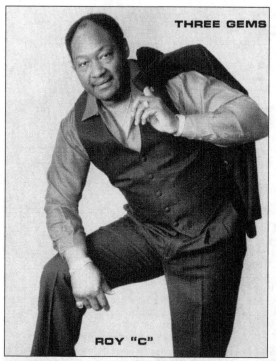

THREE GEMS

ROY "C"

Roy C, originally Roy C. Hammond, pictured here in a promotional glossy for Three Gems productions, is a soul and blues singer who adopted South Carolina as his home after growing up in New York. As talented a producer as he is a singer-songwriter, Hammond has performed alongside the Heart Beats, Tyrone Davis, Clarence Carter, Marvin Sease, Dennis Edwards, Lee Fields, Buddy Johnson Band, Don Covay, Percy Sledge, Jay Hines, Bobby Womack, Millie Jackson, Wilson Pickett, and Betty Wright. Proving the connection between soul, blues, pop, and rap music lies in their Afrocentric drumming, Hammond says his beats have been sampled by Janet Jackson, 2Pac, and Run DMC. (Courtesy of Roy Hammond.)

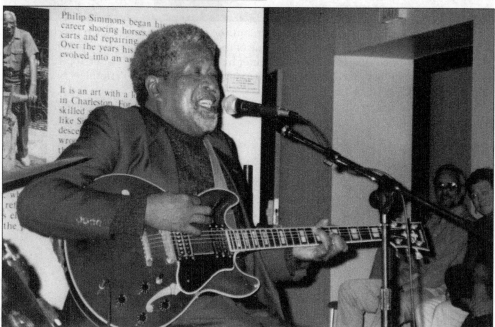

Educating as well as entertaining, Drink Small was an annual headliner at many of the South Carolina State Museum's blues and jazz celebrations. Small is well known for his rhyming folk wisdoms, called "Drinkisms," such as "With my gimmicks, the sky's the limit!" He was awarded an honorary doctorate from Denmark Technical College and was named a National Endowment for the Arts Heritage Fellow, the highest cultural award for traditional arts in the United States, in 2015. (Courtesy of Tut Underwood.)

Although Nappy Brown broke many of the color barriers in music, his career suffered from the popularity of the British invasion, which overshadowed the fame and record sales of many R&B artists. Brown continued to perform despite the downturn, spending much time overseas. He also made the most of his body when performing. Shown here with arms spread wide and reaching up to the heavens, Brown entertained audiences with his big baritone voice, emoting as he performed his hit songs "Don't Be Angry," "Lemon Squeezing Daddy," and "Night Time is the Right Time." (Both, Nappy Brown collection, courtesy Cora Garmany.)

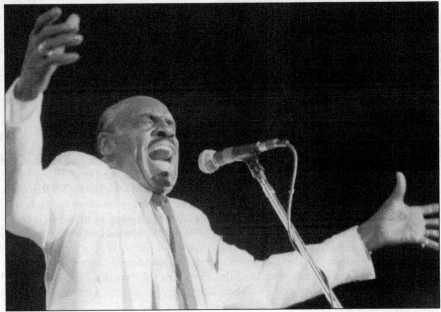

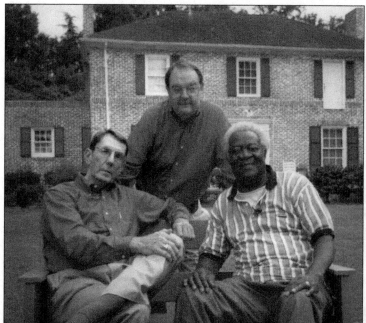

Kelly Jones (left) and Sam McCuen (center), longtime musicians and devoted fans of Bill Pinkney of the Drifters (right), enjoy a lovely afternoon reliving old times with their friend and musical idol. (Courtesy of Myra Ramsey.)

From left to right, Doug Allen, Frank Smoak, Marion "Bones" Rice, and Rick Peterson are seen here celebrating Smoak's birthday at the Mousetrap Restaurant in Middleburg Mall in Columbia sometime during the mid-1990s. Smoak's blistering guitar technique resulted in his being hired to tour with Billy Joe Royal after dazzling Carolina fans in mainstay blues/rock bands like Christopher, which recorded the underground hit LP *What'cha Gonna Do?* at the Arthur Smith Studios in North Carolina. After his debut band, Smoak played in 2201, a Cream tribute band that included Allen and that rivaled Columbia's top local band Speed Limit 35, in 1971. In turn, he then joined Joanie and Friends, Brother (also known as the Brother Band), and the Buddy Ray Band, as well as Rob Crosby and Friends before hiring on to tour with national recording acts. (Courtesy of Doug Allen.)

Four

Modern Blues in South Carolina

Old friends Maurice Williams of the Zodiacs (left) and Bill Pinkney of the original Drifters, R&B, soul, and beach music icons for half a century, greeted each other warmly and reminisced about their musical careers not long before Pinkney's death on July 4, 2007. (Photograph by Daniel Coston.)

Soul music legend and South Carolina adoptee Clifford Curry (left) acts out his 1960s hit "She Shot a Hole in My Soul" by shooting a figurative hole in the soul of his friend Gene Lee as Lee prepares to join the Sensational Epics as the band performs its top Cameo label hit "I've Been Hurt" at the 50th Anniversary Tribute to Beach Music at the South Carolina State House in 2003. (Courtesy of Gene Lee.)

Word of Mouth Productions Blues Festival cofounder Geoffrey Graves (center) welcomes Drink Small to the performance stage. Small is renowned for regaling audiences with tales about his own life put to music. His songs are unabashedly autobiographical, and at age 80, he began to work his way back from secular music to the sacred music at the heart of his musical roots. His signature song "Never Too Late to Do Right" is one that he wants everyone around the world to sing. (Author's collection.)

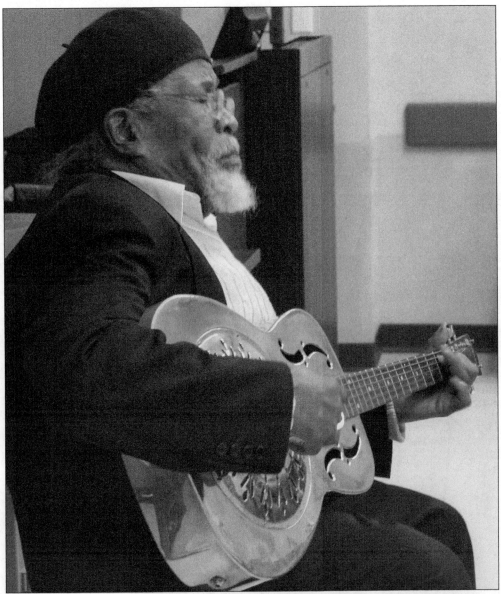

Drink Small plays his resonator steel guitar on January 28, 2013, for students in the author's Music of the Carolinas course, which was offered through the Institute for Southern Studies at the University of South Carolina in Columbia. The class members surprised Small with an 80th birthday party, complete with cake and ice cream. Small was overcome with emotion; however, it was the students who felt they received a treat when Small performed live for the class, most of whom had never heard or met an authentic bluesman before. (Author's collection.)

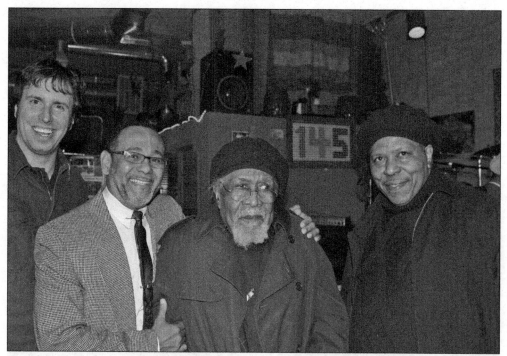

From left to right, Daniel Coston (photographer and author of *Home of the Blues*), Donald Ceasar, Drink Small, and James Lewis bundle up Small for the cold ride home from Winnsboro's 145 Club after that evening's 80th birthday tribute to Small in 2013. (Author's collection.)

From left to right, Piedmont blues harmonica player Freddie Vanderford, Drink Small, and Doug Allen wrap up a long program of entertainment featuring South Carolina musicians at the Burroughs-Chapin Museum in Myrtle Beach. Each musical artist was invited to play a short set of songs adjacent to his portrait painted by Upcountry artist Glen Miller. (Author's collection.)

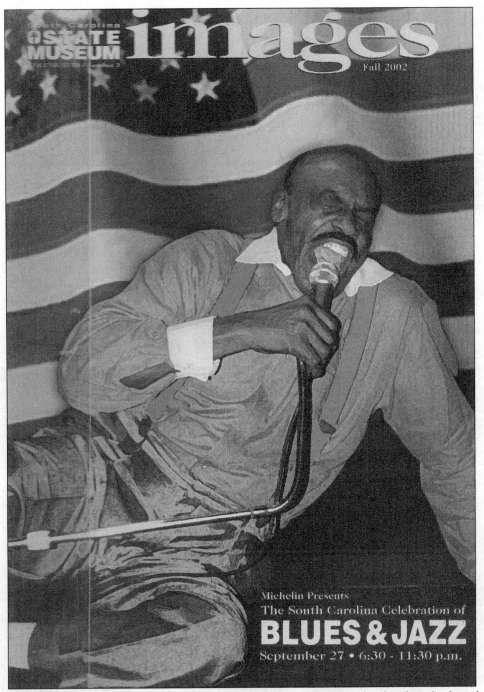

Michelin Presents

The South Carolina Celebration of

BLUES & JAZZ

September 27 • 6:30 - 11:30 p.m.

Nappy Brown often brought down the house with his blues shout style that hearkens back to the ancient ring shout dance, which inspired gospel music and blues, among many other genres of modern music. As seen on this cover of *Images*, the magazine of the state museum, Brown was a natural headliner for the annual Blues and Jazz Festival, held each year for over a decade. Brown's emotive style often resulted in stage antics, such as moaning and crawling on the floor, or doing "the gator," much to the delight of onlookers. (Courtesy of Tut Underwood.)

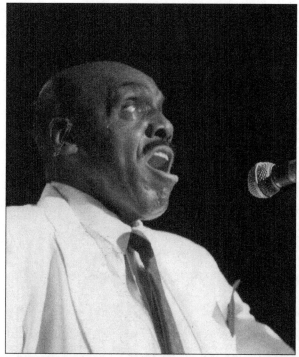

The ability to carry a note for a duration and distance is a skill that takes power, raw talent, and practice. Formal training is not required, as early blues singers of work songs and field hollers attest, but few could control their voices with the power and beauty of Nappy Brown. Here, he uses his gospel and shout band singer training to push a controlled note out and hold it for longer than most could merely hold their breath. Shout and big band singers had to sing clearly over large orchestras without benefit of amplification. Brown toured with such greats as Big Joe Turner, Jimmy Reed, Big Maybelle, and Big Mama Thornton, each of whom could, as Brown exhibits here, hold a long, powerful note without breaking it. (Nappy Brown collection, courtesy Cora Garmany.)

Cora Garmany and Nappy Brown raised a large family together in Pomaria, near Newberry. Each year, their church held a tribute to the Faithful Workers gospel choir that Cora and Nappy sang in each Sunday at their little white chapel in the pines. No matter what the occasion, their hearts and home were always open and filled with friends, laughter, soul food, and music. (Nappy Brown collection, courtesy of Cora Garmany.)

"Healin' wit' da feelin' " is what the artist known as Dr. Dixon proclaims to do with his harmonica, which he says he hears with his heart, not his ears. Nicknamed "the Blues Physician," Larry S. Dixon once lived in the Orangeburg area and became a fixture on the blues scene in the Midlands and beyond. He has played with many of the greats in blues, including Muddy Waters and harmonica powerhouses Junior Wells and Little Walter. At the South Carolina State Museum, Dr. Dixon, a visual arts teacher by day, is seen here curing what ails people. (Courtesy of Tut Underwood.)

Frank Smoak is pictured shyly looking down at his guitar as he plays in the late 1990s. His focus was nearly always on the instrument rather than his audience, but his passion and expertise consistently awed his audiences. According to Smoak's former bandmate Doug Allen, fellow musician Bruce Springsteen arrived as a guest of author William Price Fox at a Mousetrap performance. Springsteen was so impressed that he refused to leave until the last note was played and he got to query the reticent Smoak about his techniques. (Courtesy of Doug Allen.)

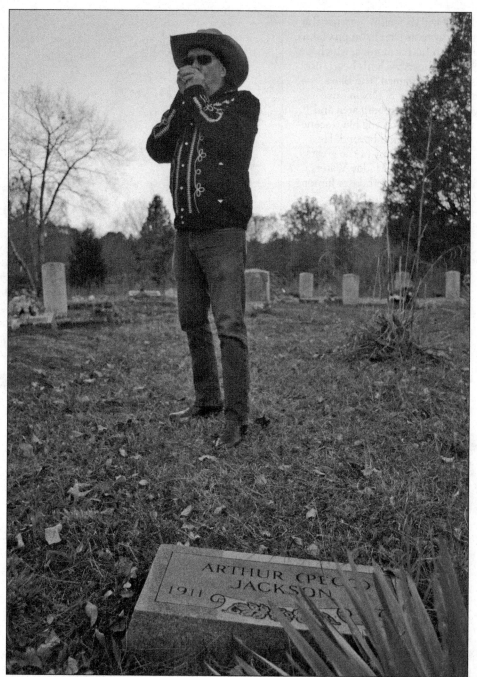

Freddie Vanderford of Buffalo, near Union, plays a plaintive song on the harmonica at the grave of his mentor, Arthur "Peg Leg Sam" Jackson. Vanderford learned to play harmonica from Jackson as a teenager, trekking many miles through the woods to Jackson's cabin. It took years for Vanderford to persuade his mentor to take him on as a student, so to earn his trust, Vanderford did chores and errands, such as fetching water because there was no running water to the cabin. Vanderford eventually earned Jackson's respect as well as the state's highest award for traditional artisans, the Jean Laney Harris Folk Heritage Award. (Photograph by Derik Vanderford.)

The Electric City Blues Band, led by Kym MacKinnon (guitar), has earned many accolades in its long history in the Upcountry of South Carolina. From working as Nappy Brown's longtime backup band to earning top honors in a statewide battle of the blues bands contest in the 1990s, this band has a winning combination of longevity and talent. (Author's collection.)

Gary Erwin (left), talent scout and promoter for the nearly two-decades-old Carolina Downhome Blues Festival in Camden, points to Laurence "Luckyman" Beall and says, "This guy is great!" Beall, a fairly recent Carolina import, has several professionally produced and highly acclaimed albums in a style comprised of blues, country, and rockabilly. He wrote a song about hoecakes (a pancake made of cornmeal) that sounds almost as fine as his homemade hoecakes taste. (Author's collection.)

From left to right, Gary Erwin (known as "Shrimp City Slim" when he performs), Big Boy Henry, and Ben Chapman are about to perform in the 1993 Charleston Blues Festival, which Erwin promoted and booked in various venues across Charleston, including the Circular Church, Mills House, Cumberland's, Mimi's Café, Wally Gator's, and Mistral. (Courtesy of Gary Erwin.)

Two South Carolina blues women from the Upcountry greet each other at the Word of Mouth Productions Columbia Blues Festival in Martin Luther King Park, near Five Points. Wanda Johnson (left) and Toni Spearman share their love of blues with a backstage hug prior to Spearman's performance after arriving from a live feature interview with WIS-TV10 NBC Columbia. Spearman has lived in Europe for decades, but both of these vocal powerhouses are from the northwest part of the state. (Author's collection.)

Mac's on Main was a longtime cornerstone of the Midlands blues community. With its blues jams, featured artists, and prizewinning cooking, along with Fatback's house band, it seemed like a foolproof formula. A new blues and jazz club, Savalis, has come and gone, leaving a gap in Main Street's blues culture and culinary continuity. In better days for Mac's on Main, Barry "Fatback" Walker (left) and Toni Spearman share a brief reunion before her sound check. (Author's collection.)

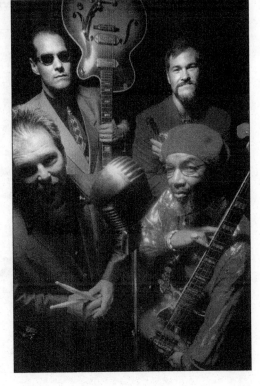

Elliott and the Untouchables have been steady on the swing and blues scene in the Midlands and beyond since the early 1980s. Often festival bound and always in demand, they have opened in European festivals for big acts like Van Morrison. Clockwise are, from front left, David Hunt (drums), Elliott New (guitar and vocals), Mike "Naz" Nazarenko (harp), and J.T. Anderson (bass). (Courtesy of Shelley Magee.)

Sometimes the music business is about the music, and sometimes it is about the business. Other times, there is a certain mojo that takes place when two great musicians meet for the first time and play together—each taking note, literally, of the other's style. Here, Laurence "Luckyman" Beall (left) and Freddie Vanderford first converge at Beall's country home for a meeting of the musical minds. (Author's collection.)

This Shelley Magee and Blues DeVille promotional picture features (clockwise from front left) band members André LeBlanc, James Lewis, Mike Fore, Shelley Magee, Marv Ward, and Todd Edmunds, who currently tours worldwide as bassist for Otis Taylor. Magee is known for surrounding herself with fine players. She tells about getting lessons on her vocal growl from Drink Small when first starting as a singer. At the start of their sessions, Small told Magee, "For the first few months, we'll work on blues moaning; then we'll work our way up to the growl." (Courtesy of Shelley Magee.)

Although much has changed since the days when playing music on the front porch was one of the few forms of entertainment, other pursuits pale by comparison to some of the finest pickers in the Midlands playing a private concert on a porch as inviting as this one. James Boyce (center) and Zack Rosicka (right) trade licks as a friend enjoys the night air and the tunes. (Courtesy of Shelley Magee.)

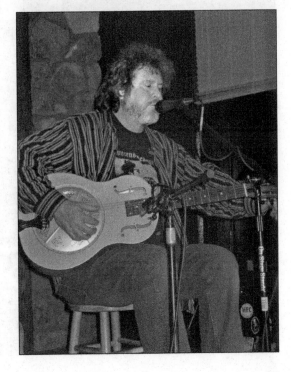

Lowcountry "outlaw" blues picker and social justice crusader Jeff Norwood appeared at the short-lived but vibrant blues venue Hard Knox on Knox Abbott Drive in Cayce shortly before his premature death. Norwood's music was deeply influenced by Piedmont country pickers, as well as those of the Mississippi Hill Country, but he was a South Carolinian through and through. Much like Josh White, he sought to fix what he thought was wrong with his state and the world. Sometimes crusaders work so hard they wear out early, and the same is true for Norwood, who left a lot of holes in a lot of hearts by dying so young. (Author's collection.)

Locals can salute the Army for a lot of things, including stationing the brilliantly talented Jeff Liberty in their midst. A passionate, fervent guitar technique, along with a dedication to continually developing as a musician and a human being, define Liberty's core values as a musician. Rarely does one encounter such power and precision in the same player. Here, Liberty plays the Word of Mouth Blues Festival with longtime Columbia keyboard virtuoso Cleve Edwards, who has composed television theme songs and played with many bands, including Lion and Nappy Patch. (Author's collection.)

Chris Reed (right), a guitarist who was in his early 20s when this photograph was taken in January 2013, joins seasoned veteran Jesse Robert Murphy of Whitmire (left) and harmonica player Juke Joint Johnny (center) of Charleston at the 145 Club in Winnsboro. Reed has the talent and passion to match riffs with the best someday—and that day might arrive very soon—so he is one to watch. (Author's collection.)

Country bluesman John Hartness is a firefighter by day but sets fires by night when he plays. Mentored by Mac Arnold, but evoking a style that is more Mississippi than Piedmont, Hartness has an easy picking style that is a match for his affable, gentle demeanor. (Courtesy of John Hartness.)

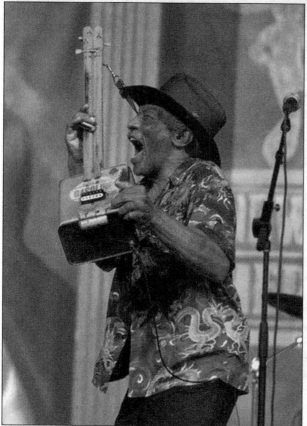

Mac Arnold's Plate Full O' Blues band references his return to his roots as a farmer. Dishing up tasty licks is no problem when the band is this good—and he has his own Blues Restaurant at 1237 Pendleton Street in Greenville. That down-home eatery features live music and soul food. Especially fortunate diners arrive on a night when they can hear Mac's gas can guitar (left), which his brother made for him when he was a boy. Members include, from left to right, Max Hightower, Arnold, and Austin Brashier, as well as Tez Sherard (not pictured). (Both, courtesy of Mac Arnold.)

This photograph depicts a modern version of the front porch lifestyle. Greenville's own gentleman farmer Mac Arnold left South Carolina as a young man to audition for Muddy Waters in Chicago, where he "got hired on the spot." He was also in the band for the *Soul Train* television series. Now splitting his time between his own band, his restaurant and music venue, and his organic farm, Mac deserves to enjoy every front porch break he gets. (Courtesy of Mac Arnold.)

Early appearances with his band, Garfeel Ruff, introduced the world to the guitar and vocals of Rickey Godfrey, who hails from Greenville. Godfrey faces many of the same issues that other blind Upcountry bluesmen Cootie Stark, Blind Simmie Dooley, and the Reverend Gary Davis faced from their visual challenges. Modern-day conveniences, such as computers that can read text aloud, make it easier, although never easy, for blind musicians. Godfrey now lives and performs in and around Nashville, with occasional visits home. (Author's collection.)

83

Harmonica player Mike Fore has been a member of many blues bands in the Midlands of South Carolina for the past 30 years. He has performed in upbeat blues bands like Blues DeVille, as well as country duos like Congaree with Marv Ward, and is regularly welcomed to sit in at other musicians' gigs. (Courtesy of Shelley Magee.)

Robert "Sonny D" Dickey grew up in Hartford, Connecticut, listening to Jazz at the Philharmonic and became inspired by Ella Fitzgerald and Charlie Parker. At age 16, Dickey played onstage with jump and swing music greats Sil Austin and Red Prysock at the Governor's Foot Guard Hall in Hartford, Connecticut, which jump-started his "Texas tenor sax sound" that can also be credited to Illinois Jacquet and Coleman Hawkins. He has played with R&B stars Chubby Checker and "Wicked" Wilson Pickett, backed the Five Satins, and performed in the house band at New York City's Knickerbocker Club. He enjoyed New York, but left northern climes to play backup for Bill Pinkney and the Drifters, as well as Nappy Brown, after serving in the military down south. He has provided his rich saxophone sound for Columbia's Elliott and the Untouchables since 2002. (Author's collection.)

Marv Ward (left), longtime resident of South Carolina, came from New England, where his early bands opened for 1960s psychedelic bands like Vanilla Fudge. Ward has been in many bands during his decades as a Southerner, including Blues DeVille and Congaree, and has issued three albums of original work. Ward performs here with Jim "Wall Street" Coulliard (center, on harmonica) in Camden during a blues festival. (Author's collection.)

Taking genre reinvention at "flat-out light speed" is the duo Flat Out Strangers, which evolved from a guitar and bull-bass-fiddle duo playing a bluegrass and rockabilly mix with a tinge of blues to American Gypsy and swingabilly in one short decade. Its gig notices are cleverly worded in a Southern hillbilly style and are as endearing as the band members' names: Sputter Jones (bull bass, vocals), Johnny Dark (guitars, vocals), Finklea Tomlinson (drums, vocals), and Junior Smitty (violin, vocals). (Courtesy of Flat Out Strangers.)

Davis Coen is one of the youngest blues and country blues players to be included as a stand-alone entry. A child of coastal Charleston, Coen has lived the life of a troubadour and now calls Memphis home. Coen manages a hectic schedule of "pickin' and caterwauling," but despite constantly being on the road, he has put out nine albums since his first in 2000, which is prolific by any standard and even more so when considering the high quality of his work. (Courtesy of Davis Coen.)

EXTERNAL INFLUENCES ON BLUES IN SOUTH CAROLINA

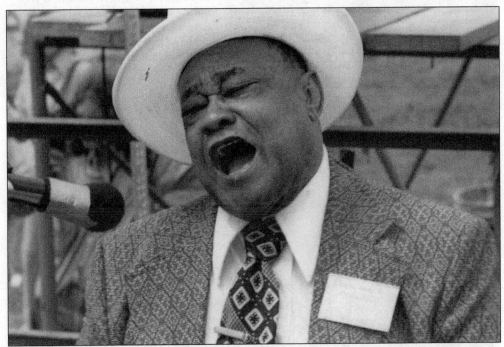

In the days when the difficulty and expense of travel kept musical styles geographically distinct, external forces did not have much effect on South Carolina's blues and roots music. With the advent of economical travel, the state's unique musical styles took on new influences, including itinerant musicians who played other subgenres of blues. One such influence was Roosevelt Sykes, who came to a studio in the city of Columbia to record an album. Many of Sykes's albums included hokum, which is also called "bawdy" or "dirty" blues. (Photograph by Jerry Cover.)

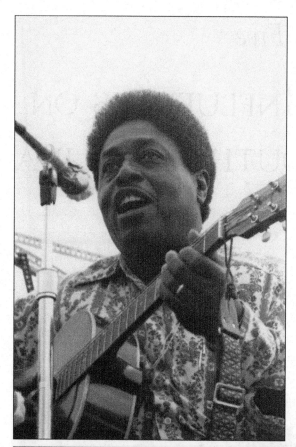

Johnny Shines's guitar work has inspired many a fine musician, among them Walter Liniger, who was born in Switzerland and studied under Shines while employed at the University of Mississippi. Liniger teaches Echoes in the Blues for the Institute for Southern Studies at the University of South Carolina, and here, he is pictured guest lecturing students in a Music of the Carolinas course about his other mentor, Etta Baker. (Left, photograph by Jerry Cover; below, author's collection.)

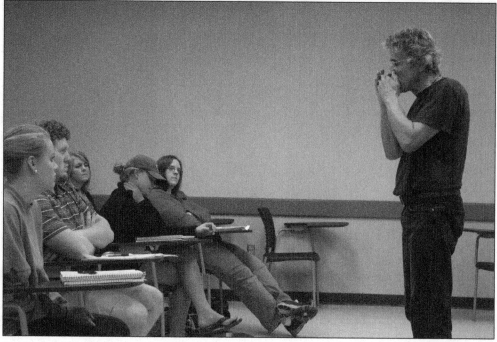

THE ALLMAN JOYS

Before borrowing Georgia neighbor "Blind" Willie McTell's "Statesboro Blues" as their signature song, the Allman Brothers performed at a show produced by legendary disc jockey Woody Windham at the Hangar on Bluff Road in Columbia as the Allman Joys. Windham believes the 98 people who paid $1 apiece in the late 1960s got their money's worth, as well as a memory to last forever. The Allman Brothers merged countrified rock with blues to create a sound that influenced a generation of blues lovers, not only in the South, but worldwide. (Courtesy of Gene Lee.)

A Muddy Waters band member reunion between Mac Arnold (left) and Grammy-winning performer Willie "Big Eyes" Smith was captured for posterity by Daniel Coston shortly before the blues world lost Smith in 2011. Arnold's engaging, affable spirit and long history of work with many of the seminal greats of roots and blues music makes him a genuine Carolina treasure. When his farm schedule allows, he performs around the country but can often be found behind the microphone at Mac Arnold's Blues Restaurant or headlining his own Corn Bread and Collard Greens Festival in Greenville. (Photograph by Daniel Coston.)

Nappy Brown (far left) is one of the musical artists who helped break the color barriers in music. Elvis Presley saw Brown perform every chance he got. From left to right are Brown, Little Junior Parker, Presley, and Bobby "Blue" Bland backstage after a performance. (Nappy Brown collection, courtesy of Cora Garmany.)

Nappy Brown (left) and "Screamin'" Jay Hawkins are seen here bowing to each other in admiration of the other's showmanship, then sharing a table after performing a duet of Hawkins's hit song "I Put a Spell on You." Hawkins had a similarly powerful bass voice to Brown's and performed a voodoo-based opening act during which he was rolled onto a smoke-filled stage in a coffin, only to arise as if from the dead while bellowing out lyrics to his heavily drum-laced music. (Both, Nappy Brown collection, courtesy of Cora Garmany.)

Longtime performer Lonnie Brooks (left) of Louisiana and Nappy Brown shake hands after sharing the stage. Brooks is a powerful guitarist who still tours and has influenced many, including his sons Ronnie Baker Brooks and Wayne Baker Brooks, who are both working blues musicians. (Nappy Brown collection, courtesy of Cora Garmany.)

Nappy Brown (left) is seen here with another exciting and energetic performer who helped break through the race barriers with his music. Little Richard Penniman, "the Architect of Rock and Roll," invited Brown onstage from the audience to perform with him during Little Richard's South Carolina State Fair performance around the turn of the millennium. The affection Penniman had for Brown is evident from his head tilt and from the broadest smile he wore all evening. (Nappy Brown collection, courtesy of Cora Garmany.)

Gatherings of friends and nationally renowned musicians were common at Nappy Brown and Cora's house. Here, a fortunate few are spending an evening in Brown's kitchen with Robert Lockwood Jr. (seated), the acclaimed guitarist who learned his Delta stylings from his famous stepfather, Mississippi's "King of the Delta Blues," Robert Johnson. (Nappy Brown collection, courtesy of Cora Garmany.)

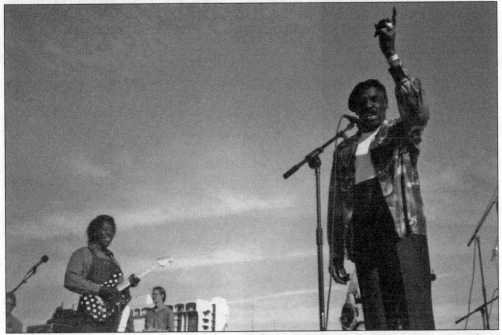

Another admirer and friend of Nappy Brown is Chicago blues guitarist Buddy Guy (seen here wearing his trademark overalls while playing his iconic polka dot guitar). Guy spied Brown in the audience and pulled him up onstage to sing, later saying backstage that he would be honored to invite Brown up on any stage at any time to sing with him. (Nappy Brown collection, courtesy of Cora Garmany.)

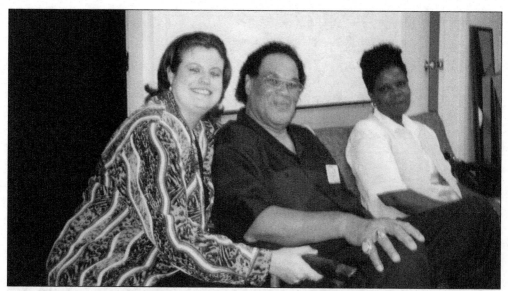

Columbia blues singer Shelley Magee (left) beams as she sits next to one of her longtime idols, Iverson "Louisiana Red" Minter, and his wife, Dora, who appeared at the Carolina Downhome Blues Festival (CDHBF) in Camden shortly before his death in February 2012. Louisiana Red left America for Germany, preferring the treatment from European fans. He befriended Magee and mentored another American blues expatriate, Toni Spearman of Greenwood, teaching them what he learned from Muddy Waters, Elmore James, Robert Nighthawk, Lightnin' Hopkins, and John Lee Hooker. (Courtesy of Shelley Magee.)

Chicago blues moaner Katherine Davis is shown here in full feathered headdress emulating the look of "the Mother of the Blues," Ma Rainey. Davis moved to Columbia from Chicago in the 1990s to allow her children to attend school "in peace" but also chose the city because of its vibrant blues scene, due in no small part to a jumping little blues nightspot in the Congaree River Vista called Beulah's. Her Carolina bandmates included Will Salley, Doug Allen, Jimmy Mac (McMahon), and (Donald) Ceasar. Davis has very much been missed since her return to Chicago. (Courtesy of Katherine Davis.)

Myrtle Beach's Charlie Snuggs (left) has backed up many national blues acts, such as Anson Funderburgh when he is without his Rockets and, as seen here, the late Bo Diddley, who found fame by bringing giouba (or juba) rhythms to modern awareness in the 1950s through his self-titled hit "Hey, Bo Diddley." Although giouba is most often played with rhythmic hand clapping and slapping of the knees and thighs or using spoons, Diddley recreated these ancient African beats using those hambone-style rhythms on guitar. (Both, courtesy of Charlie Snuggs.)

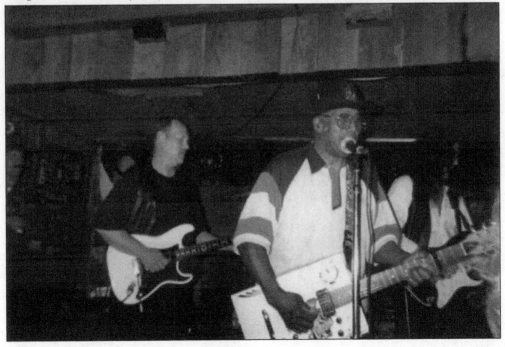

Atlantic Records was called the "House that Ruth Built," because of the success of Ruth Brown, who is seen standing to the left of one of South Carolina's Sensational Epics' horn players, Gene Lee. Brown had an inspirational comeback and enjoyed a long and storied second career after her employer, an attorney, heard her singing along to her own music on the radio as she vacuumed his carpet. Shocked by the lack of royalty payments, the attorney filed a landmark case, winning past royalties, not only for Brown, but also for others who were uncompensated by the music industry. From left to right are Rep. Floyd Spence's daughter, Liza; Sonny Turner of the Platters; Elaine Marshall, secretary of state for North Carolina; Brown; and Lee. (Courtesy of Gene Lee.)

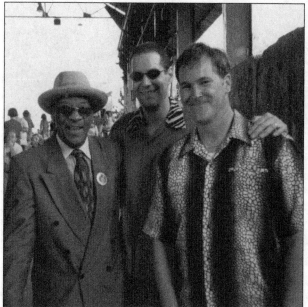

Howlin' Wolf and Muddy Waters had a competitive streak and jockeyed for position at the top of the Chicago blues heap. They did not share much, but the talented master guitarist Hubert Sumlin was a player whom they both admired. In an interview for Blues Moon Radio, Sumlin told the author that he was too young to get into clubs but sneaked in through bathroom windows so he could get onstage to play with his idol, Howlin' Wolf. He later played a year for Waters but found his style more suited to the Wolf. Sumlin (left) is seen here, about 10 years before his death, with Elliott New (center) and Mike Nazarenko of the Untouchables. (Courtesy of Shelley Magee.)

The Columbia blues cognoscenti met with the King of the Blues at Township Auditorium around 1987, when King proved the "thrill was not gone" by singing "Happy Birthday" to an unsuspecting Doug Allen and friends backstage. From left to right are John Paul Chapman, Lane Phillips, Dave Fuller, Kent Knoph, Riley "B.B." King, Rick Peterson, Marion "Bones" Rice, Darby Erd, and Allen. (Courtesy of Doug Allen.)

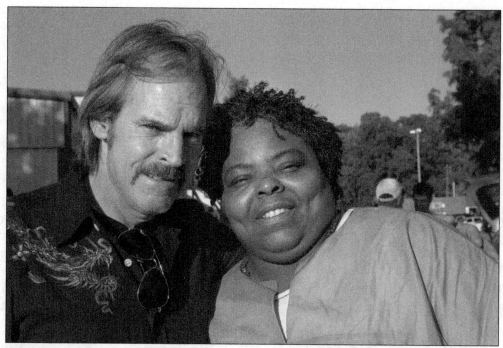

A homecoming of sorts was enjoyed by band and fans alike when the Alexis P. Suter Band came to Columbia for a blistering performance at the Word of Mouth Blues Festival. Suter's roots with the Porterfield family go back hundreds of years in the Midlands, and although she lives in New York, her family is still in the area. Suter (right), pictured here with lead guitarist Jimmy Bennett, leads her band with powerhouse vocals that rival Big Mama Thornton. (Author's collection.)

Big Daddy Stallings made his first appearance in the Midlands of South Carolina when he was born near Fort Jackson, but he grew up on a tobacco farm near the eastern shore of North Carolina. Stallings now lives in Maryland and travels around the country with a soul blues band. (Courtesy of Big Daddy Stallings.)

Six

PEOPLE AND PLACES

The most popular music station in the late 1950s through the 1970s was WCOS, featuring disc jockeys Woody Windham and Johnny Foxx, who is pictured broadcasting live. As program director, Windham invented the Top 60 playlist, which broadened listenership and kept the music rotation from becoming stale. (Courtesy of Rick Wrigley.)

WUSC's longest-running program is *Blues Moon with Clair DeLune*, which has been on 90.5 FM nearly every Tuesday evening at 6:00 p.m. since 1990. Guests of the program have included South Carolina blues royalty Drink Small and his wife, Drina, pictured above visiting on his 80th birthday, and below, Brandon Turner (left) and Freddie Vanderford as the New Legacy Duo, who played live on the air after lecturing to a Music of the Carolinas class in 2013. (Both, author's collection.)

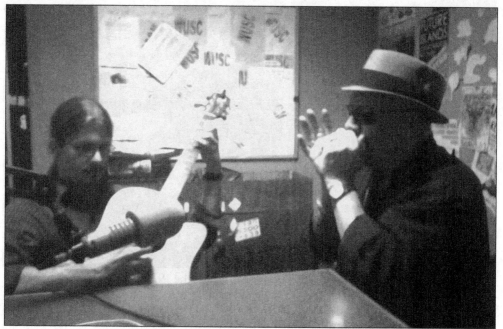

Among musician and promoter Gary Erwin's many talents was hosting the long-running *Blues in the Night* radio show that broadcast from the USS *Yorktown*, the historic aircraft carrier in Charleston Harbor. An ocean of blues emotion was emitted from those towers each week. (Courtesy of Gary Erwin.)

Finding a rare 78-rpm CD or even LP recording can be exhilarating yet frustrating for record hounds. Over the past two decades, independently owned record stores have suffered from competition from big-box stores that can slash prices as loss leaders to attract customers. But at the few remaining indie record stores across the nation, such as Columbia's Papa Jazz Record Shoppe, service and a wide selection of hard-to-find recordings bring customers back again and again. (Courtesy of Tim Smith.)

PAPA JAZZ RECORD SHOPPE
new & used records
Buy - Sell - Trade

The 1950s through the early 1960s was an era of dressing up for dates. Skirts, sweater sets, and heels were the norm for girls, and jackets, khaki pants, and ties were "where it was at" for the boys. Close dancing to slow, soothing R&B songs made it all worthwhile. (Courtesy of Gene Lee.)

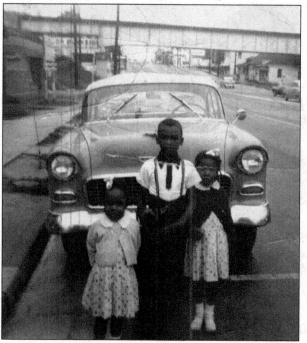

Singing artist LGB shared this evocative mid-1950s photograph that was taken in front of the old train trestle overpass on Gervais Street in downtown Columbia, near the intersection with Harden Street. Nearby venues these children would be far too young to visit included the action-packed Boogie's Grill, with its hand-painted, grammatically incorrect alert painted on the screen door that warned, "NO drunk, NO drug, and NO teenager." Ironically, not far from Boogie's was another R&B club called the Rendezvous Café, which reportedly became a favorite among the underage crowd for its policy of charging $5 for a fifth with few, if any, questions asked. (Courtesy of LGB.)

Rufus Thomas of Memphis must have had someone else "Walkin' the Dog" for him back at home while he appeared at the Township Auditorium in the mid-1960s. The mostly teenaged audience was ready for him to "sock it to them," as the popular song urged. The Township has showcased an extensive list of pedigree-quality artists on its performance roster through the decades, and no concert there has gone to the dogs. (Courtesy of Gene Lee.)

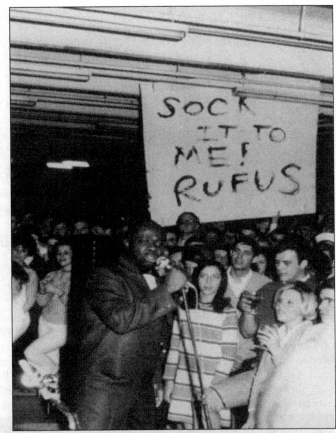

Beach music fans will remember the Beach Club owned by Cecil Corbett on the Grand Strand of the Carolina coast. (Courtesy of Gene Lee.)

Oliver's Pub became the in spot in Columbia in the early to mid-1970s. Located where Jake's is now on Devine Street, Oliver's featured stained-glass windows and an elliptical bar that fostered a flow of collegial patrons. Service was great and the bands were even better, with a long lineup of top acts routing through the place, including Dickie Betts of the Allman Brothers picking the strings of his red guitar on a lazy Sunday. Here, a bartender nicknamed "Hartley" takes a break from slinging beer to do a harp-playing photobomb of the band Seymour Light. (Courtesy of Skip Peter.)

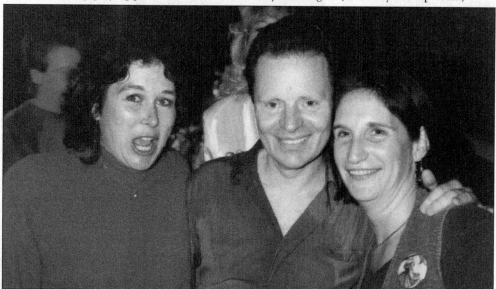

The Coal Company, which occupied the former Joyful Alternative, as well as an actual coal company in its infancy, was a bar on Greene Street near the old Claussen's Bakery, now the Claussen Inn. Delbert McClinton appeared shortly after being one of the first blues-based musical acts featured on *Saturday Night Live*, with *Charlie's Angels* star Kate Jackson as his host. McClinton is seen at the Coal Company with two devoted music lovers around 1977. (Courtesy of Doug Allen.)

Now dilapidated and on its last legs, with its porches propped up by shaky-looking stacks of cinder blocks, Jackson Station in Hodges represents the many "juke joint" style venues that have come and gone across the southern landscape over the past century. Although its floorboards are rotting through, the architecture hearkens back to the station's original purpose: providing respite to passing patrons. Later, many types of acts of local and national renown appeared at this rollicking music venue, including South Carolina musicians Nappy Brown and Drink Small, along with rootsy national acts like Poco. (Photograph by Daniel Harrison.)

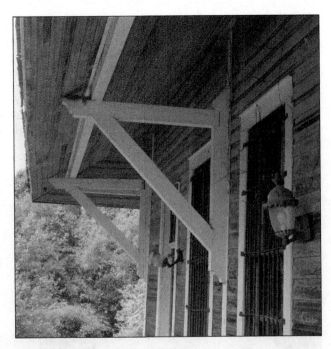

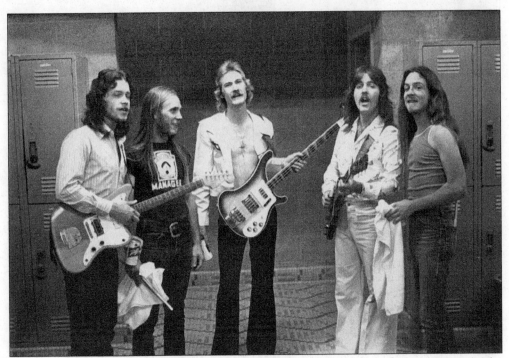

The Brother Band prepares to go onstage at the Township Auditorium as the opening act for the Marshall Tucker Band from Spartanburg, another South Carolina act that went national. From left to right are Frank Smoak (guitar), Billy Aarons (drums), Johnny Few (bass), Bobby "L.G." (lead guitar) Walker, and Tommy Toglio (drums). (Courtesy of Joy Walker.)

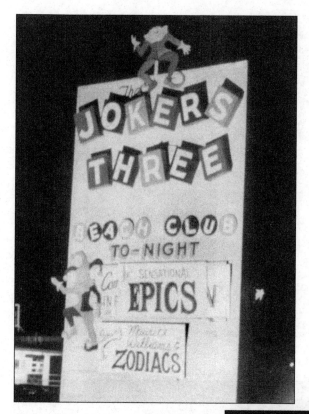

The Jokers Three helped keep the beach music scene alive through the heydays of the hippie and disco movements. Here, the Sensational Epics are billed with another legendary South Carolina beach music band, Maurice Williams and the Zodiacs. (Courtesy of Gene Lee.)

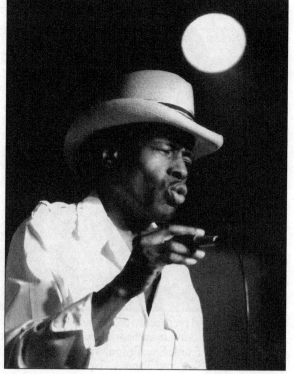

Greenstreets evolved from the Coal Company, eventually moving to a roomier location at Harden and Gervais Streets, which allowed it to expand the quality of national acts it booked. From inside the club, one would be hard-pressed to tell the difference between the entertainment in a major city and that offered at Greenstreets. Ronnie Earl, Junior Wells (pictured here in the mid-1980s), and Buddy Guy were top blues acts among the multitudes booked for Midlands blues fans' enjoyment. (Courtesy of Doug Allen.)

After Woodstock, the popularity of outdoor concerts with festival seating rose in popularity. The University of South Carolina hosted the Georgia Satellites and the Nitty Gritty Dirt Band, among other free concerts, on its intramural fields when the bands were on the brink of becoming famous. (Author's collection.)

Even political powerhouses get the blues. In this picture, crews from the *CBS Evening News with Connie Chung* film Lee Atwater's Columbia performance at Bullwinkle's, which was located across Jackson Boulevard from where LaBrasca's Pizza and Whole Foods are now. From right to left are Warren Moise, Atwater, Jackie Muckenfuss, Doug Allen, Mike Tronco, and Rick Peterson. (Courtesy of Doug Allen.)

An old green jalopy drives through the first Five Points St. Patrick's Day festival in 1983. Yesterday's Restaurant is under the giant inflatable beer can and the University of South Carolina's Capstone building, with its revolving restaurant, is at the top right. This festival has featured many roots music acts through the years on multiple stages and stands as one of the top St. Patrick's Day festivals in the nation. (Author's collection.)

Fans of Drink Small recall his many appearances at the GROW Café off Assembly Street in the Olympia Mill neighborhood of Columbia. The building was hard to miss with its mural of the Hulk bursting, trompe l'oeil style, through the walls. Certainly, the Hulk was not attempting to escape the music, which was always great. (Author's collection.)

Rockafella's was a landmark music club on the site of the former Oliver's Pub on Devine Street in Five Points, where Jake's now operates. Acts such as Koko Taylor and John Hammond attracted blues fans, but the offerings were diverse, ranging from the BoDeans to the Red Hot Chili Peppers to the shock-rock of GWAR. Shown here is the club and billboard for the last appearance of the original Nighthawks in February 1986. (Author's collection.)

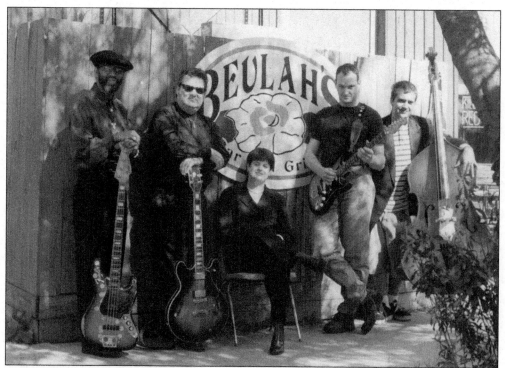

It was a sad day indeed for the Midlands Blues Society when Beulah's, its favorite haunt, closed. Beulah's only booked blues bands and kept the local musicians fed and watered with paid gigs. The players pictured on the final night are, from left to right, J.T. Anderson, Marv Ward, Shelley Magee, Jeff Liberty, and Todd Edmunds. (Courtesy of Shelley Magee.)

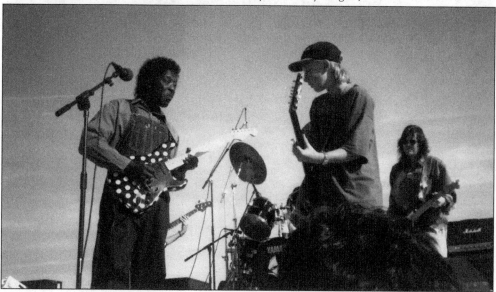

Charleston's Music Farm is known for bringing in national-level acts, and its range recently expanded to include a venue in the Vista district of Columbia. Buddy Guy (left) is pictured here with Derek Trucks (center), a then very young guitar prodigy out of the Allman Brothers franchise. (Courtesy of Tut Underwood.)

Big Daddy's on Broad Street in Camden has closed up shop, but in the 1990s, it hosted blues acts on a regular basis. Shelley Magee and the Bad Deeds rock Big Daddy's house on this particular occasion. (Courtesy of Shelley Magee.)

Camden's Wood Auditorium at the Fine Arts Center of Kershaw County on Lyttleton Street has been a fine platform for major acts at the Carolina Downhome Blues Festival for many years. Mississippi's Honey Boy Edwards (left) said he was the last person to see Robert Johnson alive. Edwards, who performed brilliantly there in the last decade of his life, was just as happy to see and perform alongside Carolina bluesmen Drink Small (second from right) and George Herbert Moore (right) as they were to play with him. Gary Erwin (second from left) wove the blues tapestry that made history that night. (Courtesy of Gary Erwin.)

Blues and guacamole? There is nothing wrong with some cultural fusion. Georgia-born Beverly Guitar Watkins, who was the first female blues guitarist for Dr. Feelgood and who plays guitar behind her head as well as in front, keeps patrons entertained at La Cantina Mexican Restaurant during a Carolina Downhome Blues Festival performance. (Author's collection.)

Fiery Ron's BBQ hosted one of the last of the Charleston Blues Bash performances. Around 2005, Muddy Waters's son Big Bill Morganfield arrived nattily dressed in a Chicago-style pin-striped suit and fedora hat, then proceeded to dazzle the crowd. (Author's collection.)

Cumberland's, another Blues Bash site, was *the* venue for blues in Charleston for many years. Blues Bash organizer Gary Erwin appeared as Shrimp City Slim with Blue Light Special. From left to right are (first row) Jay Niver and Silent Eddie Phillips; (second row) Gary Erwin, John "Juke Joint Johnny" Winkler, and Jerry "Hitman" Hiers. Hearing Shrimp City Slim and Juke Joint Johnny play "She Got Papers" is an incredible experience. (Courtesy of Gary Erwin.)

There is no known photograph of South Carolina bluesman Julius Daniels, but the organizers of the blues festival in his honor hold the event in the historic Dane Theatre in Denmark on the last Saturday in February each year. Daniels's "99 Year Blues" is featured on the *Anthology of American Folk Music* and has been covered by blues rocker Johnny Winter and country blues rockers Hot Tuna. (Courtesy of Jerry Bell.)

The House of Blues is the largest national blues entertainment franchise. Elliott and the Untouchables are pictured here performing their upbeat, swinging, horn-based blues music at the House of Blues in Myrtle Beach. (Courtesy of Shelley Magee.)

The origins of country music are closely tied to blues and African roots. Once a stringed gourd, the banjo has evolved to become a key instrument in country and bluegrass music. The lines between those genres and country blues are somewhat blurry, but their connections remain clear. Bill's Pickin' Parlor features bluegrass concerts every Friday and Saturday. Luke Winslow King arrived from New Orleans to play for a rapt audience on Meeting Street in West Columbia. Harmonizing are Esther Rose on dulcimer and King on guitar. (Author's collection.)

Two of the three cofounders of the Columbia Blues Mob, Doug Allen (left) and Vic Scaricamazza, listen to the Blues Mob's jam at Utopia when it was on Rosewood Drive, near Jim Casey Fireworks, as singer Sweet Sarah taps out time. Not pictured is Clair DeLune. (Author's collection.)

The 145 Club's Elfi Hacker is seen finalizing details for Drink Small's 80th birthday celebration, complete with a festive cake, in 2013. Hacker's club, located at 145 Congress Street in Winnsboro, kept blues solidly booked in the Midlands for several years. The 145 Club is on the market, lock, stock and beer barrel(s), and after a rousing series of farewell fetes in the late spring of 2015, it is not presently open. It is hoped someone will pick up the mantle from previous owner Hacker and again provide another reliable home for live blues music in the Midlands. (Author's collection.)

Private blues jams are the norm at blues guitarist Rick Marsh's Bluz Shak near Lexington each Tuesday night. Players must be invited to shake this shack. (Courtesy of Rick Marsh.)

Dustin Arbuckle of Moreland & Arbuckle of Wichita, Kansas, smiles at the crowd as Geoffrey Graves (right) announces the lineup at one of the 19 Word of Mouth Productions Blues Festivals in Columbia's Martin Luther King Park, brought to the community at no charge thanks to the dedication of a large cadre of volunteers, including WOMP's early founders Graves, Jay Crouch, Steve Gulley, and Chris Judge. (Author's collection.)

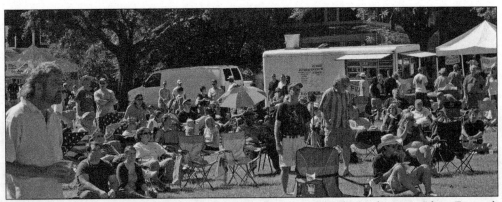

Patrons, vendors, and food trucks surround the Word of Mouth Productions Blues Festival. Somewhere down the line of trucks is the fish-fryin' wagon belonging to culinary genius Drina Small, who inspired Drink Small's song "Fish Fryin' Woman." (Author's collection.)

From left to right, Donald Ceasar, Drina and Drink Small, Elfi Hacker, and author Clair DeLune celebrate a milestone birthday in Small's life at the 145 Club in Winnsboro in 2013. (Author's collection.)

This 1865 photograph of Charleston's Circular Congregational Church paints a picture of ruin, but the inspiration of music and hope helps in overcoming trials and tribulations to rise above. Music is a means to survive trouble and gain the strength to persevere and rebuild. Ironically, this church that suffered so much destruction is now the site of many uplifting blues performances. The Circular Church has come full circle in its story of hope and jubilation. (Courtesy of LOC.)

Seven

REMEMBRANCES

This Beulah's menu evokes memories of eating on an outdoor deck to the accompaniment of blues music. Since Colonial times, when social and culinary activities were conducted outside because of cramped living quarters, blues and casual foods like barbecue forged a permanent partnership over the smoky fire pit. Although blues fare includes more than barbecue, there is always a decidedly down-home flavor. (Courtesy of Shelley Magee.)

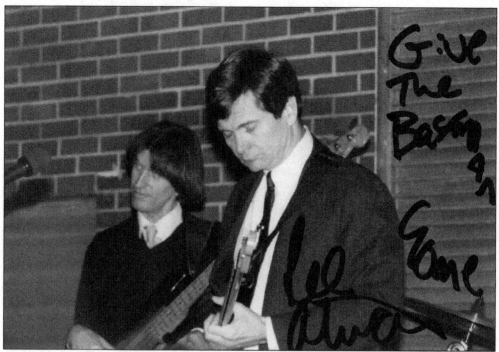

"Give the bassman some love," the inscription from Lee Atwater to Doug Allen, denotes the importance of what is known in blues as "the bottom end." Melodic guitars added an important element to the blues, and since the 1960s blues and rock era, the top end has become the prime focus of modern music fans. With his words, Atwater immortalizes the concept that the original source of all Afrocentric musical styles is the rhythm from bass and drums. (Courtesy of Doug Allen.)

A Rolodex, Filofax, or other business/calling card file system was the Facebook of the day in the mid-century. The more things change, the more they stay the same. In the music business, connections affect popularity, and the quality of one's "list" affects a musician's success. Having this rarity containing the Drifters' phone number was what was known as "a get." (Courtesy of Gene Lee.)

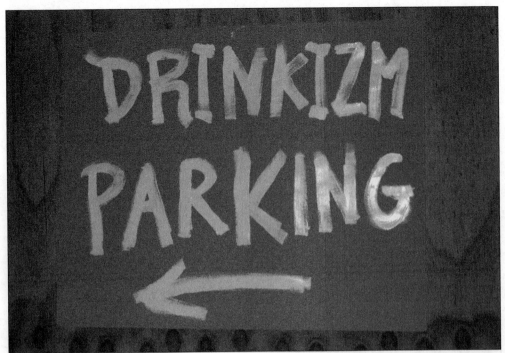

A misspelled folk art sign points to parking for a benefit on Frink Street in Cayce for Drink Small, alluding to his pearls of wisdom about life, which are called Drinkisms: "Can't go with the Devil; but you got to go through the Devil to get to another level; hit the Devil with a shovel; to get to the next level." (Author's collection.)

Nearly 20 years of the Carolina Downhome Blues Festival, sponsored by the Fine Arts Council of Kershaw County, has resulted in a huge economic uptick for the state and an immeasurable increase in cultural awareness for attendees. But perhaps most importantly, the festival has vastly raised international awareness of the value of the state's cultural heritage. (Courtesy of the Carolina Downhome Blues Festival.)

Much like the Carolina Downhome Blues Festival, other events coordinated by artistic director Gary Erwin have resulted in South Carolina's increased visibility on the world's cultural roots map. The Lowcountry Blues Bash, Greenwood Blues Cruise, Kiawah's Blues by the Sea, Florence's Pee Dee Blues Bash, and many more annual celebrations of blues and roots music are musical gems that, when compiled over many years, become a treasure chest of musical culture, making South Carolina shine ever more brightly. (Courtesy of Gary Erwin.)

Countless hole-in-the-wall bars once populated downtowns across the state. Many offered live R&B and blues, such as Harold's A-Go-Go on Gervais Street in Columbia. As time went on, these establishments would come and go, until live music became the exception rather than the rule. Gone but not forgotten are venues such as the Other Place, New South Music Hall, Twilight, Copper Door, Green Door, Wagon Wheel, Myskyn's, original Handlebar, Fountain Bleau, Boogie's Grill, the Palace, Sylvester's, Sand Dollar, Campus Club, Mimi's Café, Turtles, Beau's, Mary's Supper Club, Greenstreets, Coal Company, Oliver's, Rockafella's, Hard Knox Café, Mac's on Main, and the 145 Club. Innumerable others live on only in memory. Clubs need patrons to survive, and musicians need venues that offer live music to keep the culture vibrant, so ultimately, the most important factor in maintaining cultural vibrancy for a music genre is a broad, supportive fan base. (Courtesy of Gene Lee.)

My Guitar Name Is Geraldine

① My Guitar Name - Is Geraldine
My Guitar Name . Is Geraldine
When Me + Geraldine . Get Down
All My Friend . Just Stand Around
I Dont Use . A Wa-Wa
I Jest Play A Plain Guitar
Geraldine . The meanest Guitar
You Ever seen Oh Yes

② My Guitar - Is A Guild
When I Play It - The Girls Get A Thrill
All The people . Near And Far
Like Geraldine . Thats My Guitar
Everytime I Play A Funky Run.
Somebodys says . Play That sonable . Gun
One Lady says I like The way you play
I said I . Do A woman The same way

③ Everytime . I Bend The Strings.
Somebody Says . Play That Thing
About . The Time
I'm playing Real Mean
Sobody Says Go Geraldine

④ USE

This is the original draft of the lyrics to Drink Small's song about his long-lost guitar, Geraldine. According to an early Blues Moon Radio interview with Small, who often uses third-person references, "Drink doesn't drive so that's how I lost Geraldine. I got a ride in the seventies with a friend from our gig to Boogie's Grill, which was a black club down on Gervais Street in Columbia that had a sign painted on the screen door reading, 'NO: Drunk. Drug. Teen-Ager.' We were having some fun, then my friend had to leave, so I accepted a ride with another man that my friend had been talking to, so I thought my friend knew him. I needed to make a call, so this guy let me off at a corner pay phone on the way home, but before I knew it, that man had driven off with Geraldine in the backseat and I never could find who that man was or how to get my guitar back. Geraldine was gone for years until Rick Marsh found her in a pawn shop. He didn't know it was mine until Doug Allen recognized it, and Rick gave her back to Drink Small, God bless him." (Photograph courtesy of Shelley Magee, handwritten lyrics courtesy of Drink Small, copyrighted by DrinkTron Publishing and may not be reproduced further without express written permission.)

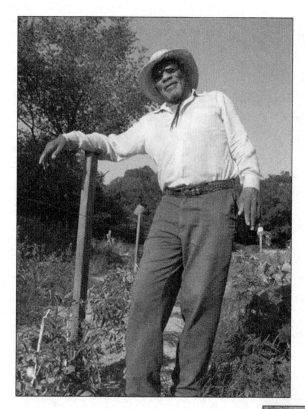

Proof that it can be good to return to one's roots is in the smile on Mac Arnold's face as he assesses the produce from his organic farm. He sings that return-to-roots story in the song "Backbone and Gristle" from his 2008 album of the same name. It is a story with universal truths—ones that hearken back to sharecropper days and speak to the enduring spirits of the first African Americans who faced unfathomable challenges yet proved they had more than enough backbone to survive. (Courtesy of Mac Arnold.)

Making the most out of what a person has by using what he or she has got in creative ways has been a survival technique for blues musicians through the ages. Although crudely made folk instruments are now manufactured to look authentic, these gas can guitars made for Arnold were born of necessity and handmade with love by his brother in the mid-1940s. Elliott New of Elliott and the Untouchables also plays a gas can guitar. (Courtesy of Mac Arnold.)

Friendships forged through music can last forever, as this picture of three old friends attests. Buddy Guy (left) and Sam McCuen (center) chat while the often reticent Nappy Brown looks on. (Nappy Brown collection, courtesy of Cora Garmany.)

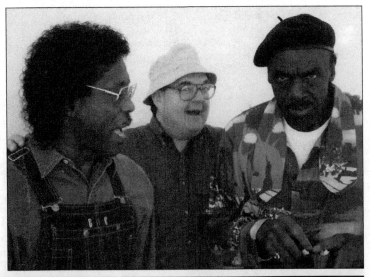

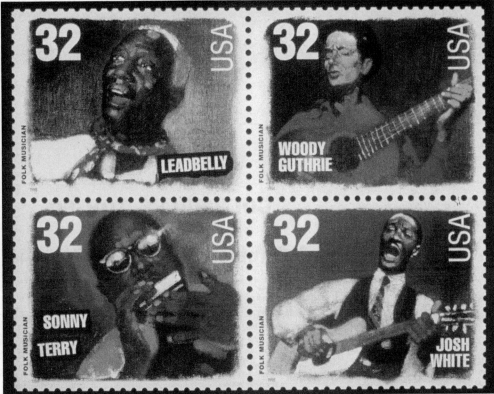

Each of these collectable postage stamps has a South Carolina reference. Lead Belly sang a song about "The Winnsboro Cotton Mill Blues." Woody Guthrie's granddaughter Sarah Lee Guthrie and her husband, Johnny Irion, lived in West Columbia in the early 1990s and often performed at Café Streudel on State Street. Sonny Terry performed throughout the state in the early part of the past century along with his singing partner, Brownie McGhee. Last but not least, South Carolina's own shining star Josh White sings out against injustice. (Courtesy of United States Postal Service.)

Collections of ticket stubs—whether kept in a drawer, a shoebox under the bed, or carefully archived in a scrapbook—are keepsakes of treasured experiences. Ticket stubs from the Handlebar at the old mill in Greenville, the now demolished Workshop Theatre on Bull Street in Columbia, and Asmer's Other Place on Bush River Road in Columbia commemorate more than mere musical memories. These tiny, torn, and sometimes autographed scraps of pretty paper also immortalize cultural institutions. (Author's collection.)

Even Newer
WCOS
Columbia, S. C., 1400 kc

COLUMBIA'S TOP 60
from
Columbia's Top Music Station

Rating This Week	SURVEY WEEK	Position Last Week	Rating This Week	Dec. 10 THRU Dec. 17	Position Last Week
1	I'VE BEEN HURT...SENSATIONAL EPICS	20	31	MONEY...JR. WALKER	40
2	DEVIL WITH BLUE DRESS...MITCH RIDER	1	32	WHISPERS...JACKIE WILSON	18
3	TRY MY LOVE AGAIN...BOBBY MORROW	13	33	I'VE GOT THIS FEELING...NEIL DIAMOND	27
4	HOLY COW...LEE DORSEY	2	34	THIS SIDE OF TOWN...RIGHEOUS BROTHERS	19

Rating This Week	SURVEY WEEK	Position Last Week	Rating This Week	DEC. 31 THRU JAN. 7	Position Last Week
1	I'M A BELIEVER...MONKEES	2	31	COLOR MY WORLD...PETULA CLARK	--
2	TRY A LITTLE...OTIS REDDING	4	32	WHAT YOU'VE DONE...POZOSECO	57
3	SHADOWS OF LOVE...FOUR TOPS	15	33	BUT'S IT ALRIGHT...J.J.JACKSON	16
4	I'VE BEEN HURT...SENSATIONAL EPICS	1	34	NO ONE ELSE...SUNNY & SUNLINERS	--

Long-conserved samples of the WCOS Top 60 hit parade emphasize the staying power of the Sensational Epics' song "I've Been Hurt," which was in the Top 10 for an entire month. (Courtesy of Gene Lee.)

In 1992, Columbia's Blues Festival began in Yesterday's parking lot in Five Points. It was founded and produced by Steve Gibson, the original owner of Rockafella's. Soon after, Word of Mouth Productions volunteers continued the tradition, with a legacy of 20 annual free blues shows featuring top national acts as its gift to the citizens of the state. WOMP endeavors to bring world-class roots musicians to perform in Columbia for its free festival each year but always has a strong underpinning of local talent from the broad talent pool in South Carolina. The brainchild of Geoffrey Graves and Jay Crouch, with Steve Gulley and Chris Judge rounding out the original leadership, the festival would not come to life without the countless hours of work done by hundreds of WOMP volunteers and donations from the City of Columbia and its other much-appreciated benefactors. (Courtesy of Word of Mouth Productions.)

Pictured here is the most recent festival banner, one for Word of Mouth Productions' 19th, drawn in an R. Crumb style that hearkens back to 1970s Bay Area concert posters, also making wordplay of the classic Rolling Stones song "19th Nervous Breakdown." It might have been prescient because a funding shortfall in 2014 marked the first gap in annual programming. However, this world-class event is slated to resume in the fall of 2015. (Courtesy of Word of Mouth Productions.)